MANAGING DESIGN FOR PROFITS

Managing Design For Profits

First edition in Spanish 2008

Edition © 2010 by Index Book, S.L.
Texts © 2010 by Xenia Viladas
Design© 2010 by DFraile

Consell de Cent 160 Local 3. 08015 Barcelona
Phone: +34 934 545 547 Fax: +34 934 548 438
ib@indexbook.com
www.indexbook.com

Author Xenia Viladas
Design DFraile
Translation Shawn Volesky

Printed in China

All rights reserved. No part of this publication may be reproduced, stored in a retrieval system, or transmitted in any form or by any means, electronic, mechanical, photocopying, recording, or otherwise, without permission of the copyright holder.

ISBN 978-84-92643-39-4

MANAGING DESIGN
FOR PROFITS

Xenia Viladas

To Mariona and to Pol.

Contents

- *9* Introduction
- *21* I Design? What design?
- *37* II Design as a strategic function
- *51* III A company's design policy
- *69* IV Managing design
- *79* V Organizing design in a company
- *89* VI The resources required for design
- *103* VII The design brief
- *113* VIII The design project
- *127* IX Evaluating design
- *151* X The next step: design thinking
- *159* Conclusion
- *167* Appendix 1: on design
- *183* Appendix 2: the process of selecting designers
- *195* Appendix 3: the network of design services
- *205* Appendix 4: the keys to a reputation in design
- *213* References
- *217* Online references
- *221* Acknowledgements

Introduction

When I first joined the Barcelona Design Centre in the 1990s, we essentially worked for two types of customers: "design companies" and, well, everyone else. It goes without saying that design companies were few and far between, and the others, for the most part, regarded design as little more than an extra expense that had no impact on the bottom line.

Things have changed since then, and today's situation represents a complete about-face. Nowadays, design is one of the core competencies a company must have if it wants to enter—or stay in—the market, and slowly but surely, it is taking its place in a new type of production function, where creativity rubs shoulders with quality and user surveys rank up with financial analysis.

Even so, by its very nature, design is creativity and change, which from a rational perspective translates into uncertainty and risk. This begs the question: how do we manage such risk?

The solution began taking shape in London in the 1970s, when an interdisciplinary group of professionals from the fields of design and management met to lay the groundwork for a new discipline, Design Management. Their reasoning was simple and can be summed up in a single sentence: if we would like to use design in a business environment, then we first need to learn how to manage it like any other productive resource.

"DESIGN MANAGEMENT MOVES DESIGN FROM BEING A GAMBLE TO A MANAGED SET OF RISKS" (J. BESSANT)[1]

Management models exist to control the risks associated with the introduction of design as a business function. Such models serve as ordered sets of guidelines that help companies make decisions throughout the business cycle and can easily be adapted to fit an organization's size, strategy and corporate culture.

However, before many companies even reach the stage of choosing and validating a particular management model, there are a number of recurring issues that hinder design's proper integration into the business. What exactly is design? How do you choose a designer? What resources should a company use to leverage investments in design? How do you measure the profitability of design? These and other questions have been debated time and again, and there are still no clear answers.

With this book, I would like to contribute to the debate and provide food for thought on these issues. It is my hope that my ideas will clear up questions and encourage more companies to embrace design as a tool for improvement and growth.

My discussion will begin with a classic definition of management and its four aspects—analysis, planning, implementation and evaluation—and will then use these aspects to structure the nine additional topics that follow. The tenth and final chapter will consist of a reflection on design thinking, which is really more of a projection for the future.

This book is structured as follows:

THE ANALYSIS STAGE:
1. Design? What design?
 Every organization, ranging from those that use design as a simple stylistic resource to those that see it as the linchpin of their corporate strategy, must determine what design can do for them and adopt a stance with respect to it.
2. Design as a strategic function
 If we take into account design's role in the creation and configuration of a company's "visibility vectors", i.e., the image it projects in the market and the way it conveys its value proposition, it becomes a strategic function and should be treated accordingly.
3. A company's design policy
 Every company's design policy is unique, because it is defined by the two previous questions. The contents of the policy determine both the end goal and the steps required to get there.

THE PLANNING STAGE:
4. Managing design
 The position that design management occupies relative to the company's highest level of decision-making and its relationship to other functional areas affects its effectiveness and its ability to achieve established goals.
5. Organizing design
 Decisions on the size and structure of the design department, whether or not to outsource design and if so, which parts to subcontract (amongst other operational aspects) ultimately determine the viability of projects.

6. The resources required for design
 No company can expect design to be profitable without giving it the material and human resources it needs to unleash its full potential. Also, given that design is a creative function, these resources may be unconventional at times.

THE IMPLEMENTATION STAGE:

7. The design brief
 Controversial as it may be, the design brief is a crucial management tool that serves to organize design projects and guarantee measurable outcomes.
8. The design project
 A company's design policy will eventually take shape in a series of design projects. The more that is invested at the beginning of the project, the more time is gained and the more is saved on costs.

THE EVALUATION STAGE:

9. Evaluating design
 Though there are no exact measurements, there are reasonable ways to measure return on expectations (ROEx) and return on investment (ROI). This is one of the major challenges of Design Management.

A REFLECTION FOR THE FUTURE:
10. The next step: design thinking
 Design puts people at the heart of a project. It uses a combination of intuition and methodology to provide innovative solutions. It is global and specific at the same time. It is quick but does not neglect detail. It gives companies the tools to create a solid foundation before the fact. For these reasons, many people see design as an advantageous management skill that can help companies overcome the challenges of today's market and ensure their long-term success. According to the latest theories, design is the management skill of the future, a hypothesis that should be taken very seriously.

Each chapter is extensive, and all are interlinked. Even so, I have also tried to afford some degree of separation in order to help clarify concepts and keep myself within parameters that are reasonable for a text that is not intended to be a textbook or encyclopaedia, much less a thesis on Design Management in business.

ABOUT THIS BOOK

SO, WHAT IS THIS BOOK ABOUT?
In this book, my editor and I chose—from the discipline's many and varied fields of application—to talk about Design Management as a tool for businesses. We take "business" to mean any organization that must operate in a market and, as a result, deposits its trust in design in one form or another. In this respect, I refer to businesses in the traditional sense, whether for-profit or non-for-profit (e.g., a restaurant or an NGO), as well as public or state-owned enterprises (e.g., schools, metropolitan transport companies, furniture manufacturers or even town councils).

WHO IS THIS BOOK FOR?
I wrote this book thinking of readers who are in charge of smaller businesses and organizations, much like those I interact with on a daily basis as part of my professional activity.

I would also like to underscore for readers that I am writing from the perspective of a developed economy in a country in the northern hemisphere in the 21st century and that as a result, the concepts of design, risk, well-being, society, needs, etc. that I employ are those we commonly use here and now. If we were somewhere else in the world, this text would most certainly be different.

WHAT IS THE PURPOSE OF THIS BOOK?
The purpose of this book (or its intended purpose at least) is to help businesses make decisions that will reduce the number of mistakes and failures related to poor design

<u>management and will increase their return on investment in the field of design</u>. My intent is not to provide set solutions to be accepted at face value, an impossible task, so much as to suggest questions that ought to be taken into consideration. Naturally, each and every one of the thoughts I bring up in this book will find a unique echo and response in every organization that finds its way to these pages.

…AND HOW DOES THIS BOOK WORK?
The text is structured around the ten themes described in this introduction, ordered following a scheme that will be found on the fold-out back cover. You can leave it open as you read as an aid to understanding.

The book also includes four annexes, which examine specific themes (design, the process of selecting designers, the network of design services, and the keys to a reputation in design), and a bibliography with text as well as Internet references.

Diagrams and small tables are scattered throughout the text to summarize and clarify concepts and to make it easier for readers to recall the information for later use in day-to-day management. Drawings have also been included to make for a more pleasant reading experience. The drawing sometimes illustrate a concept, and other times, they are there simply because the designer and I liked them.

BY THE WAY, WHAT IS NOT INCLUDED IN THIS BOOK?
This book does not contain recipes (though it does mention food) nor models (though more than one is cited). I have deliberately avoided in-depth analysis of technical matters that other specialists can address more authoritatively, such

as topics related to the protection of design or the details of financial accounting. Also, I have not included a directory of design-related organizations; there are already others in wide circulation. However, for every (conscious) omission, I refer the reader to the source I think most relevant or indicate the resources I find most useful.

AND FINALLY,
The tools and concepts that I offer on these pages are merely suggestions that readers will have to "customize" and make their own, integrating them into their own particular management style and using them as they see fit. With this idea in mind, I have left some blank pages at the end of the book for readers to jot down any thoughts that come to mind as they read.

In short, this book is not a treatise on Design Management; rather, it is a "Swiss army knife" to keep in your pocket for everyday use.

1. Bessant, 2005

I

Design? What design?

Design is an exceptional way to improve companies and, by extension, society as a whole. But in the business world, there is no such thing as DESIGN in capital letters; rather, there is the *design* that individual companies use according to their individual needs and possibilities.

To avoid mistakes and misunderstandings, the first thing we must do is establish an internal definition of design.

WHAT DO I MEAN BY DESIGN?

It is difficult to define what design is and what it is not. It has been the subject and - indeed - continues to be the topic of many lofty treatises and extensive formal discourse. Rather than vie with the classics in the discipline, I will limit myself to design for business purposes and will try to offer a more utilitarian view of the topic.

To do so, I will use a series of descriptors that characterize design rather than define it. Appendix 1 contains a more in-depth discussion of each of these descriptors; however, by way of summary, they shape the function of a design project as follows:

- Creativity is one of its key components.
- The project follows a clear methodology.
- The project is the product of a conscious decision, not chance or habit.
- The project responds to people's explicit or latent needs.
- The project strives to meet the specific objectives set out in the job assignment.
- The freedom of the project is limited to a degree (in terms of budget, time, etc.).
- The project achieves results that can be evaluated according to previous specifications.

THE FUNCTION OF DESIGN IN A COMPANY

If we tap the full potential of design and do not limit ourselves to its most trivial aspect, i.e. giving shape, design fulfils three major functions:

IT IDENTIFIES VALUE.
Using specific research techniques that it has adopted from social sciences like sociology, anthropology, ethnography and psychology, design is able to pinpoint market trends, interpret peoples' needs, and distil this information into a form that can be used to develop goods and services.

IT ADDS VALUE.
Design brings this information to the product development process but abides by the limits of the production process - budget restrictions, time limitations, etc. - to create a new, one-of-a-kind response that stands out in the market for its originality.

IT COMMUNICATES VALUE.
It is important for consumers and users to perceive the intrinsic value of a product. The job of design is to make this value visible, giving it shape and applying the most effective form of communication.

When examined from this point of view, design does not see to the product; it looks after the "product as system". An object is not an object. It is the summary of its characteristics, its shape and the way it is presented in the market. Here, we are talking about design as a whole, not the various specialities of

design that have traditionally been taken one by one (graphic design, industrial design and interior design, as they were called in the past, or product design, communication design and space design, as they are known nowadays).

I must emphasize one point that is key to understanding this text. When I say "product", I am not talking about an object but rather a productive activity. That is to say, "product" refers to the sum of the **goods and services** produced by a company.

The basic requirements of a product designed in this way will vary depending on how it is used, but generally speaking, all products require:

Functionality: The product has to do or be what it was designed for.

Economy: The modes of production and distribution most appropriate to the product must be used to save money and resources in materials and processes.

Usability: Efforts must be made to make the product as easy to use as possible to individuals.

Aesthetics: The product must be as attractive a possible so that people will like it.

Respect for the environment: Nowadays, this condition has been adopted by most companies - both manufacturers and service providers. To show respect for the environment, a good design must reduce the product's impact on the natural environment all along it's lifecycle.

Naturally, these conditions are all relative. Aesthetics, for instance. The economic component as well. Market conditions are in a constant state of flux, and prices and the availability of raw materials vary from day to day and from one market to another. Functionality is relative if we accept that leisure is a necessary activity and validate the production of gadgets.

Usability can vary depending on the group we are trying to target, since factors like age, culture, and physical constitution affect how we use certain objects and understand certain visual codes.

IN SHORT, EVEN THOUGH IT IS VERY IMPORTANT, FORM IS NOT DESIGN'S MOST IMPORTANT CONTRIBUTION.

DSŇ-
[:DI
ZA
JN]

THE USE OF DESIGN

In addition to agreeing on what we mean by design and its purpose, we need to go one step further and explain how we will use it in a company context.

Some years back, the Swedish Industrial Design Foundation, SVID[2], developed the so-called "design ladder" model in order to group companies according to their design maturity. (See graphic on next page.)

In this model, the lowest rung of the ladder is occupied by companies that do not design, and the highest level is reserved for those that use design as a tool for innovation. The middle rungs are for companies that use design as styling and those that see it as a process. The model also purports that companies climb up the ladder little by little as they perfect their knowledge of design and improve how they use it to achieve their corporate goals.

The design ladder enjoys a certain degree of recognition in the design world. It has been employed in many different studies and has been used to develop new classifications and scales of measurement. For example, there are now attempts to develop a six-step ladder in order to reflect the various steps of perfection at the higher end of the ladder. Beyond "design as innovation", the newer models add "design as strategy" and "design as philosophy" or as a "management tool".[3]

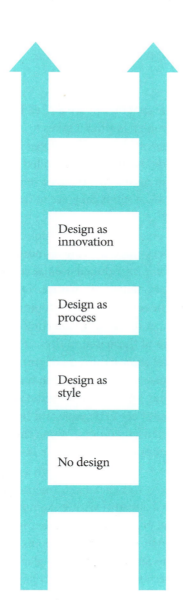

The various levels of the design ladder are:

NON-DESIGN:
These are companies that do not see a need for design and maintain that everyone has what it takes to conceive a product. Of course, regardless of whether or not they use design, all companies put products and services up for sale and have a visual identity and areas for corporate or retail use. In the absence of design, the systems they use to develop these are:

Tradition
Their models are perpetuated without change, and any modifications that are introduced are the result of informal stimuli and are not systematic in nature. Take, for example, a patisserie that has never felt the need to update its selection, decoration or service. It may have charm; however, since the owners are unaware of these issues, they are not bothered to notice changing customer habits, developments in eating patterns, or even something as simple as a change in the parish schedule. They keep on making the same complex pastries and cakes that are expensive and become less and less popular with their customers. When they start to notice, they have lost their appeal and are forced to shut down.

Copies
Their products follow already existing examples in the market. They see a successful product and limit themselves to copying it with some small variation (or "deprovements" as some call them) so that no one can accuse them of plagiarism. Because the product was not a result of an internal development process, the company finds itself at a loss and cannot make changes when

the market no longer accepts its product, and they must go out and copy again. Copying is a good way to learn, and many well-known companies probably started out this way. However, to learn from copying, the company has to see it as a learning process. If not, it will always be two steps behind the competition, it will also copy the mistakes, and when it does come across a successful product, other companies with reap the fame (though that is not always the case, unfortunately).

STYLING:
Design is used solely to give the final form of a product after it has been designed in the technical department. The product's innate qualities may be very competitive in and of themselves, but it may contain irrecoverable errors if design is limited to mere styling. For example, think of an industrial-use coffee grinder. The company designs the grinder and then asks a designer to give it a "pretty" outer shell. At this point, the company can no longer make changes to the grinder's control functions or the noise made by the motor - to cite just two examples. Perhaps the product will be a success because of its modern look, but if customers are disappointed by its use, they will not be repeat customers and even worse, they will not recommend the company. On the other hand, if a designer had been present when the idea was first being developed, his or her knowledge could have been brought to bear in the product design, and the innate quality of the product would better match its perceived quality.

PROCESS:
The company understands that designers need to be part of the product development team from the very beginning and implements a good design project management methodology. The company might even have a design department, and its products are successful in the market. However, design is not looked to as the source of new product ideas. The initiative is taken by marketing or comes directly from production with input from the sales department. On the basis of market research and surveys (i.e. on the basis of circumstances in the past and static information), the company launches correct products but does not change its competitive environment. For instance, a company might launch a beautifully designed video game with excellent special effects, but the type of game will probably be like another game already on the market. If it is not better all around, it will never become a top seller in its segment. What's more, it will never impose its idea of what the future of video games should be like.

INNOVATION:
Design helps propose new products and uses specific research techniques to do so. The company is much better at identifying market opportunities and defines product attributes much more quickly. In doing so, it creates new product categories and brings them out before its competitors. Innovation is, by definition, something that is new and successful on the market. In this respect, design guarantees innovation, because it ensures that the product will be easy for users to understand and adopt, regardless of how sophisticated its technology is or how complex its processes are. For this reason, design is an efficient, accessible form of innovation for companies, irrespective of their size.

STRATEGY:
For companies at this level, design is not only used to develop new products; it is also what gives shape and form to their corporate strategy. These companies usually possess a strong brand identity that is maintained impeccably in everything that appears on the market. These types of companies are often part of the home furnishings or fashion industries and do not compete on price or quality. Quality is a given, and price is relegated to the back burner. People who buy their products or use their services do so as proponents of a brand philosophy.

MANAGEMENT:
This idea, which is just beginning to take shape, suggests that the education characteristically received by designers is that needed by modern-day business persons. It also implies that in order to steer their way through such complexity and pressure for real time information, companies must be intuitive, curious, attentive to budding trends, user-focused, and sufficiently prudent to engage in testing all along the way but daring enough to take risks on one-of-a-kind concepts. Companies at this level must constantly ask themselves "And what would happen if...?", the same question designers learn in the early stages of their education. We will go into more detail on this option in Chapter 10.

The design ladder model is useful for classifying the attitude of a company or organization when it comes to design. However, in my opinion, this attitude does not necessarily go hand in hand with progress or improvement. From a management perspective, it is very debatable whether all companies need to be at the highest rung or need to be there at all times and in everything

they do. What is true, however, is that with each step, companies make better and better use of design's potential, and in this respect, the model is useful for companies that are just beginning to travel down this road.

AT ANY RATE, THE DEGREE TO WHICH AN INDIVIDUAL COMPANY WOULD LIKE TO OR INTENDS TO USE DESIGN AND THE "CORPORATE" DEFINITION IT USES, PROVIDES - AS WE WILL SEE LATER ON - EVERYTHING WE NEED TO DEVELOP A DESIGN POLICY AND IMPLEMENT A WELL-OILED, FULLY INTEGRATED STRUCTURE THAT SUPPORTS STRATEGIC GOALS WITHOUT PUTTING PRESSURE ON COMPANY OPERATIONS.

2. See more about the Swedish Industrial Design Foundation online.

3. For instance, the "Certification of best design practices" by the National Institute of Industrial Technology (INTI) in Argentina; see more about the INTI online.

II

Design as a
strategic function[4]

Design plays a crucial role in the conception and configuration of a company's "visibility vectors" (product, communication and space), i.e., the vehicles that convey its identity to the marketplace. In this sense, design has a strategic function and its implementation must be rooted in the company's value proposition.

THE "VISIBILITY VECTORS"

The reasoning is simple. Our first impression of a company or organization, its tangible and/or intangible expression (i.e., the product or, in the case of services, the famous touchpoints), differs from case to case. In most situations, there are dozens of products that can perform the same function, but their specific contents and appearance vary depending on the company they belong to. Think of a shelf in a supermarket, for instance. There may be as many as fifty different items in the same product category. Some will be more classic and others, more innovative. Some will carry the hallmarks of cheap production, while others will exhibit the features of high-end sophistication. The same is true for most things from automobiles to machine tools, from catering services to books. Every product is—and has—a means of presenting a company in the marketplace in relation to its strategic position. Moreover, all of a company's expressions in the market have a conceptual and formal coherence, because they represent the same value proposition.

The vehicles that communicate a company's identity to the market are what I call "visibility vectors" (VVs), and there are three types:

<u>Products,</u> whether goods or services and, in most cases, a combination of both.
<u>Communication</u> as applied to different support media (corporate image, packaging, etc.).
<u>The spaces</u> where corporate activities are carried out (offices, factories, workshops, booths at trade fairs and sites in hyperspace).

Every organization has different VVs, and their relative importance varies depending on their corporate activities and their particular business philosophy. A bookseller who delivers her customers books riding a scooter and charges her clients a fixed monthly fee is technically involved in the same business as the Internet bookstore Amazon, but their visibility vectors are not quite the same.

A vector is "a magnitude, which, in addition to quantity, includes a point of departure, direction and sense".[5] A company's visibility vectors:

- Rely on its strategic values, which define the company and set it apart from others.
- Have direction to the extent that they are conceived for a specific market, market niche or target group.
- Follow a predefined course, because they are intended to achieve a strategic goal, which is the company's raison d'être and what underpins all its efforts.

In effect, the company makes itself known in the market by way of these "vectors", which convey the essence of its strategy to customers.

In the last chapter, I asserted that different companies use design in different ways depending on their needs and their corporate culture. For some, design will only be used to give shape to these "visibility vectors", whereas for others it will take an active role in their actual creation. Still in others, design will come into play in the process of management or developing strategy. Nonetheless, in each of these situations, we can say that design has a strategic function.

STRATEGIC ANALYSIS

Strategic analysis is the tool that allows us to understand what a company is, how it sees itself, how it plans to evolve, and what (strategic) resources it will use to achieve its goals. Aligning the VVs with this definition or strategic stance helps companies fulfil their purpose, and it is important for a company to identify its strategic resources so that design can apply them when conceiving or giving shape to the VVs.

The method I use for strategic analysis is an adaptation of the Haberberg and Rieple model,[6] whose application is summarized below.

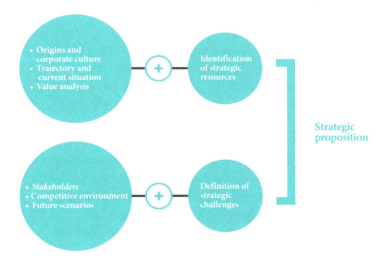

In relation to this, I would like to make the point on four issues:

STAKEHOLDERS:
Stakeholders refers to any agent who has a specific stake or interest in the day-to-day operations of an organization or company, including employees, shareholders, competitors, suppliers, the various levels of the public administration, etc. It is important for a company to be aware of its stakeholders and gauge their potential influence in order to understand how they will affect the strategic moves it has put in place and, at a basic level, whether they will assist or hinder them. This is true as a general rule but is also relevant for design-related activities.

STRATEGIC RESOURCES:
Strategic resources are any of a company's available assets, skills and capabilities that simultaneously provide:

- Differentiation, because they are difficult to acquire and replicate.
- A cost advantage, because they give value and cannot be replaced with money alone (e.g., experience).

It is very difficult to filter out which of the resources of a company are truly strategic, and as a rule, they are few in number. Even so, they constitute the foundation for the path of growth of the company and are the resources that design must elaborate and project out in the marketplace.

THE STRATEGIC PROPOSITION:
Most corporate strategy manuals condense the strategic proposal into three parts: mission, vision and goals. This simplification is a useful way to synthesize so complex a

topic, but in the end, every organization is free to describe its strategic proposal however it sees fit. There is no objective reason to summarize it this or any other way. After all, the strategic proposal is nothing more than a synthesis of what a company is and wants to be and a vision of how it intends to achieve its goals.

VALUE CHAIN ANALYSIS:
The value chain model[7] as we know it is a useful analytical tool, but the fact that it is static makes it a little outdated, in my opinion. The act of defining the diverse operations performed in a company as a string of separate events has its roots in manufacturing and responds to a vision of organizations based on physical processes. That being said, I still think that the essence of the model, which consists of if and how we add value to each of the stages of production, is relevant to designers, a point I will touch back on later.

Depending on its particular corporate culture, an organization may conduct any of a number of types of strategic analysis. At this point, the variables that can be controlled and modified are the intensity, detail, extent and degree of formality of the analysis. Some companies will limit themselves to the classic three: mission, vision and goals. Others will embark on lengthier explanations. Still others will spend months on strategic analysis, while some will finish in a matter of days. Every company has its own style. From a design perspective, the end goal of the process is to have a clear idea of what characterizes and differentiates a particular company from all the rest, so that these features can be embedded in its VVs.

THE STRATEGIC STANCE:
EXAMPLES[8]

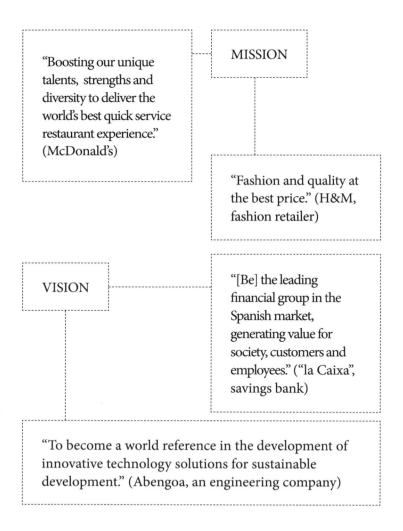

"Through its name, the Natura Bissé brand conveys the perfect union and balance of two clear values; NATURA: essence, nature, body, matter, freshness and BISSÉ: seduction, style, elegance, glamour and luxury." (Natura Bissé, cosmetics)	VALUES

- Mutual trust
- Innovation
- Eagerness for success
- Excellence at work
- Responsibility in value creation
- Participation
- Customer orientation

(IKUSI, electronic systems)

From the point of view of design, the strategic stance is interesting as a way to determine the values that, from a corporate perspective, should be included to convey a proper image of the company. The goal here is to identify the strategic assets that make a company unique, so that they are accurately reflected in the company's design policy.[9] This does not mean that every one of an organization's products (goods and services) should look alike; rather, the idea is for the organization's presence to be consistent across the market, both in terms of content and form. Here, it is important to keep in mind that we are talking about the essence of things, not their outside appearance. For instance, the essence of Camper shoes would be the concept of simplicity, which is closely related to the company's origins. Simplicity, in the sense of an absence of excess adornment, is just as effective in high-heeled shoes for a party as it is in a pair of espadrilles to wear at the beach, or just as relevant in a hotel for executives in Barcelona as it is in a boutique for fashion victims in Tokyo.

The other major aspect to identify at this stage is the company's corporate culture in order to ensure that its design policy suits its way of doing things. This will help prevent the kind of misunderstandings that can sabotage even the best of designs. It is important to keep in mind that the highest level of decision-making in a company, the CEO,[10] must feel intimately involved in how his or her company presents itself in the market. When this is not the case, companies as often as not run out of steam shortly after implementing their new design policy. Then, the slightest setback turns into an excuse to backtrack and slip into old company routines.

When this happens, it is too simplistic to blame it on a lack of awareness of design issues in the company or say that the

company does not take design seriously enough. The problem may also be that the design in question was developed under a poor awareness of the corporate culture.

This may seem confusing, because organizations often develop complicated strategic definitions. At times, they are even down right cryptic and cumbersome. How can a company distil out strategic values that can be translated into product design and environment?

> A good example is the Sony corporation. At the present time, there is no mission statement or vision to be found on its rather extensive corporate website. Since leading companies no longer talk about strategy, I expanded my search until I finally managed to locate the definition of what they call the "Sony spirit" in the "Careers" section. This definition talks about a spirit of freedom, open-mindedness, a fighting spirit to innovate and employee satisfaction. This is a reference to their corporate culture, and the text is accompanied by a photo of the company founders roaring with laughter as they arm-wrestle.[11] Is this what has to be translated into product design?

Although it may not seem clear at first on paper, experience does yield a pattern. The more clearly and conclusive a company defines its value proposition, the easier it will be for design to incorporate it into the product (using the definition of product as a system as defined in the previous chapter) and the better the product will support the company's overall strategy.

How to move from value proposition to design is the focus of the design policy and the topic of the next chapter.

4. I acknowledge the fact that in business circles, strategy is no longer hype, and other terms, such as philosophy, style, core values, etc., are now in use. However, for the sake of simplicity, I will continue to use the word "strategy" in its classic sense all throughout this book.

5. Translator's note: Here, the author uses the definition of "vector" found in the Dictionary of the Royal Academy of the Spanish Language. No equivalent definition was found in English, though the working definition in Wikipedia as of December 2008 is: "a vector is a geometric object that has both a magnitude (or length), direction and sense, i.e., orientation along the given direction".

6. Adrian Haberberg and Alison Rieple, 2001 and 2008.

7. The value chain model was proposed by M. Porter in 1995 and has been in use ever since.

8. All of these examples were drawn from the respective company websites in April and May of 2008. See the Internet resources section for the specific URLs.

9. Of course, the market environment is also integrated as a part of the strategic analysis.

10. For the sake of simplicity, from here on out, I will refer to the highest level of decision-making in a company as the CEO (Chief Executive Officer).

11. Information captured from Sony's website as per september 2008.

III

A company's design
policy

Design is what gives a product its personality. It is involved in every stage of the product, from concept to commercialization, creating a continuum of meaning rooted in the values that typify the company and make it unique.

Today's companies are facing a complex and changing business environment with economic conditions that are difficult to anticipate, due to stiffer international competition as new countries enter the market and revolutionary new technologies burst onto the scene. Nowadays, business is less about what a company can do than whether, and how, this is made accessible to its customers. Products have to be able to defend themselves on shelf at the supermarket, on websites, and at trade shows in far-off locations. To do so, they need to stand out and communicate in their own language.

Various pieces of information must be taken into consideration when formulating a design policy. These include:

- The results of strategic analysis.
- Market information and the strategic challenges ahead.
- The composition of the company's product portfolio.
- The resources available.

This information is brought together in the form of a solid course to follow in order to optimize investments and clearly project the values of the organization.

WHAT DO I MEAN BY DESIGN POLICY IN THE COMPANY?

A design policy sets out how things are done in a company and focuses on issues, such as:

- The VVs design will be used for, the extent that will it be used, and the spirit that defines it.
- Whether the company will strive to align all of the VVs to its corporate image or establish a complex system of identifying markers.
- Whether the company plans to renew its style frequently or is setting long-term guidelines.
- Etc.

Continuing with the example from the previous chapter, one of the main links on the Sony home page leads to "Sony Design", where it states that "Sony Design's core design philosophy was born from Sony's corporate philosophy". The company then expounds on this definition, explaining that:

"Sony Design aims to create an attractive lifestyle by unifying the Sony Group's assets, particularly in electronics, as well as games, entertainment, mobile communications, and others. Sony Design takes on the challenge of realizing user experiences that are unique to Sony." In the "Philosophy" section, Sony Design goes on to describe its design philosophy as "building high-performance, easy-to-use and beautiful products with a distinctive Sony flair" and cites its core values: originality, functionality, usability, and lifestyle (meaning that Sony products are not developed as mere products but as ways of shaping how people live).

The task of bringing company values to the forefront and translating them into design terms is almost never simple or straightforward, but for a company like Sony, there is no other way. Anyone who knows the history of the corporation would be hard-pressed to imagine it developing classic products, contentedly following trends, or making super sophisticated products with limited usability.

ALTHOUGH IT IS IMPORTANT FOR THE VARIOUS EXPRESSIONS OF AN ORGANIZATION TO PROJECT THE SAME MESSAGE, IT TAKES MORE THAN ALIGNING ITS VVs TO ITS STRATEGIC DEFINITION TO MAKE A DESIGN POLICY.

I also consider the following aspects to be part of a company design policy:

- The organization of design as a function in the company (which is analysed in another chapter).
- The implementation of a design intelligence function (monitoring the market from a design point of view) as a way to compare company activities with those of other organizations and constantly work on new ideas.
- Selling design and its outcomes internally as a way to ensure that resources are allocated for an effective deployment of the design policy.
- The stance of the company when it comes to protecting design.
- Actively managing a reputation in design as a way to bring in a profit from the various spheres of public life.

"DESIGN INTELLIGENCE"

Earlier, I cited the ability to pick up on signals from the market and fuse them into products as one of the values of design.

I CALL THIS FUNCTION "DESIGN INTELLIGENCE", AND IN IT, I INCLUDE BOTH TRAINING, WHICH IS ESSENTIAL FOR KEEPING DESIGN UP TO DATE, AND SCOUTING FOR INFORMATION.

Scouting means establishing a system to actively monitor any activities related, close or otherwise, to design that occur in an area defined as particularly relevant to the product in question. This area may, of course, be geographic; however, companies can also choose the limits of a product category or industry, focus on a particular discipline, or—why not?—even combine a number of different areas.

By way of illustration, a Spanish street furniture manufacturer might be interested in developments in the street furniture markets in Spain, in France, which may be its main competitor, or in the Netherlands as a benchmarking exercise against state-of-the-art competitors. It might take note of advances in "general design" or ecodesign as something to use in its products. It may also want to keep informed on automotive design, where the major trends in form, materials and concepts are first introduced, only to later work their way out into the rest of the market. Finally, it must be up to date on things that are happening in society. Watching people's habits, for instance, led designers to come up with the considerably successful one-seater public bench.

In this day and age, most companies do their monitoring with the help of Internet notification systems, which are offered by large search engines and specialized companies. However, other useful activities also include visiting the websites of major design-related organizations, both domestic and foreign, and checking out the results of awards and competitions. If a company does not have the in-house resources it needs to perform these activities, it can always outsource them; it will be difficult to find something that is design focused, but this can be replaced by a similar product focused, say, on innovation, which will also provide an excellent overview of developments in the market. Of course, there is no subtitute for the personal experience of a designer out in the street, shops and public places, observing people, objects, messages and surroundings and making sense of codes that may be useful in his or her later work.

It may seem obvious, but this information must be circulated throughout the organization for it to benefit from this knowledge and for the culture of design to make its way to all of the departments. It is essential to find how to share news, whether through a newsletter, scheduled chat sessions, etc.; every organization has its own modes of internal communication.

SELLING DESIGN INTERNALLY

Sometimes, the design policy that an organization would like to phase in is complex and may even be expensive, especially for companies that are just getting started. Suddenly, it feels like no one is talking about anything else, and it seems as though the entire expense budget will be sunk in design. Sometimes, companies implement projects that are confidential or entail considerable risks, and on occasion, the design policy may threaten other departments or the structure of the company as a whole.

The process of ushering design into a company usually comes hand in hand with a change in philosophy and a transformation in how it perceives the market and its own competitive proposition, even if only because the decision is based on a thorough strategic analysis. At times, this may shake the foundations of the organization and stiffen the attitudes of some who see changes in their everyday routine as a result of the new modus operandi.

HOWEVER, DESIGN CANNOT THRIVE ON ITS OWN IN A COMPANY. IT MUST ESTABLISH A CLOSE RELATIONSHIP WITH THE OTHER FUNCTIONAL AREAS IN THE FIRM, MEANING THAT IT IS IMPORTANT TO "SELL" DESIGN INTERNALLY.

I am including an outline based on the balanced scorecard (BSC) model as a tool to help visualize the various levels in play and the arguments needed to sell design internally in a

company that requires systematization, such as a large corporation. (See graphic below)

Balanced scorecard

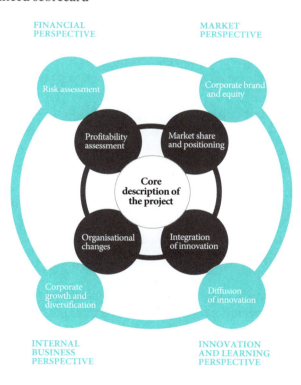

- ◯ **Project management level**
- ▬ **Division level**
- ▬ **Corporate level**

Naturally, this outline may differ depending on the type of organization in question and the functional relationships between the corporation and its divisions. It may also be adapted for selling the design policy as a whole or an individual project. In any case, the following are the issues that must be addressed to clear up any suspicions and garner support:

- From a financial perspective, the projected profitability of the design policy and the amount of risk the company is willing to accept.
- From a marketing perspective, how design will contribute to the value of the brand and its position in the market.
- From the perspective of internal business processes, the likelihood that design will bring change to the company or initiate paths of growth and diversification.
- From the perspective of continuous improvement in the organization, the integration and diffusion of innovation that design entails, examined from both a process and results orientation.

The advantage of the model is that its applications are easy to visualize and promote an intuitive understanding of the topic as a whole. It can also be adapted to the specific needs of any particular situation and serve as a platform for exchange with other parts of the corporation.

For smaller companies where there is little need of a formal model, I prefer the concept of what is known as a "design champion". A design champion is the person who believes in design and promotes it in the company, fervently defending it to the point where he or she becomes its champion in the face of potential detractors. In small

organizational structures, this role often falls on the shoulders of the CEO, and design champions frequently emerge when a company is handed down from one generation to the next. Younger managers who take the reins are often more inclined to incorporate design as a function than their older predecessors. As a result, they defend the idea of design and hire professional designers to improve their products and communication and value them adequately. This may cause friction with older or more conservative employees, who do not see the need to squander away the budget in such activities, and the new manager-cum-design champion will have to be persistent and convince the others, demonstrating the value of his or her decisions. There are also times when the role of design champion is not borne by the management, but rather by a person with influence in the company. For instance, I remember a retired marketing director from a multinational firm who kept on as design champion in an advisory capacity. At any rate, design champions are motivated individuals who know how to convince others and gather support, and most importantly, because they themselves are convinced of the value that design can bring to the organization, they know how to sell it.

PROTECTING DESIGN

I have suggested that the decision whether or not to legally protect design is part of the design policy of a company.

First things first, it is not always necessary to register a design; the chance to do so[12] and the specific option chosen from the variety of formulas available will vary on a case-by-case basis.[13]

> MUCH AS THE NUMBER OF PATENTS IS USED BY COMPANIES TO MEASURE THE QUALITY OF THEIR INNOVATION POLICY, THE NUMBER OF REGISTERED DESIGNS IS ALSO A GOOD WAY OF APPROXIMATING THE QUALITY OF A CORPORATE DESIGN POLICY.

Given that it is relatively cheap to protect the various forms of design, I am of the mind-set that design should be protected, all design, even if only for preventive reasons or for its appraisal.

Protecting design—and intellectual property in general—should be left in the hands of specialists, who will help decide how best to protect the design and how best to document it in a way that will stand up in court. In terms of legal issues, no legal action is ever taken unless two products coincide and collide in the market. When they do, it is absolutely essential to determine which of the two was there first, because it will have precedence over the other. Registration, of course, makes priority easier to prove. The Achilles heel of design protection and what most people criticize is that when conflicts do arise, an important step is figuring out where the two products overlap. Sometimes the

commonalities are both plain to see and easy to assess, but other times, the similarities are details whose importance is only perceptible to experts in the field.

MANAGING A REPUTATION IN DESIGN

Companies are not alone in the market. They are not alone when they use design or when they share the results of their efforts. For this, there are a series of agents in the market who can help them improve and get the very best out of their experience.

As excellence in design becomes a threshold competence, that is to say, design is already one of the basic competencies a company must have before it even thinks of setting out on the market, some companies may start feeling the need to build a reputation of excellence in the field, confident that doing so will bring value to the company name, especially among the "stakeholders" who are most instrumental in the success of the company.

There are a number of tools available for doing so, which I will analyse in more detail in appendix 2.

- Contests and awards.
- Exhibitions.
- Conferences.
- The media.
- Trade shows.
- Professional associations and special interest groups.

As a result, design takes its place alongside brand as one of the "reputational assets" of the company, which, as Haberberg and Rieple explain, "can facilitate access to a source of financing or a better staff of employees."[14]

ALSO, WITH A REPUTATION IN DESIGN, CONSUMERS AND PRODUCT USERS FEEL LIKE THEY ARE CONSUMING A STYLE THAT HAS BEEN VALIDATED BY A HIGHER ENTITY AS IS THE CASE WITH DESIGN AWARDS THAT HAVE DEVELOPED SOME STATURE IN THE MARKET.

In short, the design policy of a company includes:

- Setting global goals for design in line with the strategic definition.
- Fine-tuning the management of the design function.
- Implementing the following accompanying tools:
 » Design intelligence.
 » The sale of design internally.
 » Design reputation management.

12. In the EU, Council Regulation (EC) No. 6/2002 of 12 December 2001 grants some limited protection to unregistered designs.
13. Up-to-date information on the various systems for protecting intellectual property can be found on the websites of, among others, the Design Council and, in the specific case of Spain, Impiva.
14. Haberberg and Rieple, 2001

IV

Managing design

The standing of design in a company depends on its weight in the corporate strategy. The more important it is to the company's strategic definition, the closer it will be to the highest level of decision-making and the more freedom it will have to act in the organization.

MAKING DESIGN-RELATED DECISIONS

Companies are usually told that design should report directly to its top decision-makers if they want to get the most out of their investment. However, as we have already discussed in an earlier chapter, I would once again like to insist that this depends on the particular role that design plays in the company. It may be true that it is easier to coordinate the "visibility vectors" and project a clear image of the company values to the market when there is greater proximity between the top manager and the head of design. In

> THE LESS STRATEGIC A ROLE DESIGN HAS IN THE COMPANY, THE FURTHER IT WILL BE FROM THE BOARD OF DIRECTORS ON THE CORPORATE LADDER.

companies where this is taken to an extreme, the highest level of decision-making (the owner or CEO, as the case may be) also has the last word when it comes to design. But beware! This person should be at the helm of the company design policy or design management, not the implementation of individual design projects. Between the two is a line best left uncrossed.

According to a relatively recent study in France,[15] 75% of all company managers (owners and directors) take an active role in the creation process. When all is said and done, the ranks of most organizations are full of "silent designers",[16] especially in marketing, sales, at the CEO level, etc.

Design is not about personal likes and dislikes, and its tasks are better left in the hands of trained professionals. Later, I will talk more about the issue of selecting designers, but at this stage in the game, there is one point I need to make clear. The design director, or the owner or manager in the case of smaller organizations, will combine his or her vision of where the company wants to go and how it plans to get there with information from accounting, sales and marketing to make decisions related, for instance, to:

> THERE IS AN ABUNDANCE OF OPINIONS AND A LACK OF CRITERIA IN MANY COMPANIES WHEN IT COMES TO DESIGN.

- Raising or reducing the design budget.
- Hiring a new or more personnel or making cut-backs in the current staff.
- Reorienting a new division of the company using design criteria.
- Asking for advice when it comes to adding new criteria to a product, communication or space. For example, he or she may want to foster the importance of sustainability and promote it through design to help it extend all throughout the company.

Under no circumstances should the CEO or managing director participate in the implementation of a project, unless he or she has specific training in design.

MANAGING DESIGN
AND OTHER FUNCTIONAL AREAS

In many companies, design falls under the umbrella of the marketing department. Others see it as an aspect of product development and file it away in the technical office to await orders from production. Every business is a universe in and of itself, and each does what it wants - or what it can. Still, taking design as I have defined it here and demoting it to the status of function in another department effectively nips many of its potential advantages in the bud.

For the full benefits of design to blossom, it needs to be a functional area in its own right and have an equal footing in the company's decision-making processes. It goes without saying that it will have an especially close relationship with marketing and production, because the three will have to work together to come up with new products and bring them out on the market. I also recommend a tight-knit bond with finances, because without their help, there is no way of implementing any project, design or otherwise.

Due to the type of education designers usually receive, they cannot be inconvenienced with issues like finances and the economy. Similarly, in their quest to lower expenses, financial managers often undervalue the contributions of design. Companies need to work to overcome this situation and foster understanding from both sides to ensure the best possible conditions and maximum success of their projects.

DESIGN MANAGEMENT TOOLS

Where can you find design management models? Since 1989, the discipline has had access to a superb reference model, the British Standard 7000,[17] which breaks down the processes and contains an astoundingly complete menu of instructions for anyone who wants to delve into even the most minor of details. Another resource from the United Kingdom is a guidebook published by the Design Council and Pearson Education called the *Design Atlas*, which takes a progressive look at each step of the process, gives advice on how to implement the various steps, and provides tools that can be used to assess the results. A third resource, the book *Design Management*,[18] contains an array of other models that have been used over the course of the years. Its author, professor Brigitte Borja, has also set forth a new model based on the balanced scorecard in a recent publication. Other approaches are regularly described in speciality publications. Any of these models may be valid depending on the culture of the organization and the management style of the people who intend to use them.

Further guidance may be found in ISO 9001, which also includes a section on design that may be used as a template, though it is not very extensive. And because we are talking about ISO 9001, for companies that are certified and require the same of their suppliers, there are ISO 9001 design service companies to be found, at least in Spain.[19]

FUNCTIONS OF THE DESIGN MANAGER

The particulars of this position depends on everything I have discussed up to this point and are especially contingent on the specific goals set in the design policy and the position of design in the company. These factors, when taken together, determine the scope of the decision-making power of the design manager.

One of the tasks of the design manager is to make sure that the company's VVs are coherent and constitute an adequate reflection of the company values.

In the early days of corporate image development, it was common for company image programs to cover every last detail of the company look and demand strict adherence to their specifications. As a result, design managers became something of "logo cops" whose sole purpose was to comb through every use of the company image to find violations of the corporate identity manual and correct them. This is still a potential function of design managers, but today's market is considerably more tolerant than it once was and not only accepts different ways of expressing a message, but even appreciates them. With that in mind, it may be better to build up corporate image from a foundation of dynamic systems of signs than to base them on static, invariable symbols.

COORDINATING THE VVs

Take, for example, a law firm. The "visibility vectors" for a law firm are:

Product: its legal advisory services.

Communication: through its stationery (business cards, letterhead, e-mail templates) and the way it presents documents (folders, binders, etc.), brochures and its newsletter.

Space: its offices, which are not limited to the distribution of the space itself but also include the lighting, signage, decoration and the website.

The firm has a strategic stance that gives it its own identity vis-à-vis the competition. For example, it may be more family or more corporate, large or small, local or international, set up around one famous lawyer or based on the collaboration of equal-ranking peers. As a business, the firm also has a strategic goal, be it to grow, to surpass its competitors, to specialize in a particular field, to be more profitable, to increase its goodwill for eventual sale, etc.

The person in charge of the firm's design policy will take all of these indicators into account. He or she will also keep a close eye on what competitors and are doing, including general service companies that are not involved in the legal business, and will decide on the next steps to

take based on the time and resources available.

The goal is to develop visibility vectors that mutually reinforce each other and work hand in hand to uphold the strategic stance of the firm. If the law firm in question is a small family business, the secretary should answer the phone with a warm, personal greeting; the office should include some homestyle furnishings; and the website should be simple and intuitive. On the other hand, a company that offers legal services for large companies on a global scale needs to express the idea of efficiency and openness to the world. Its website should be available in several languages and have an intranet for customers, and its offices should follow the latest trends in business interior design.

Design management needs certain resources and a specific organization to effectively carry out its purpose. This is something I will discuss in the upcoming chapter.

15. Design France and Tremplin Protocoles, 2002.

16. *Silent designers* are individuals who interfere in design-related decisions in the company, even though it is not their job and they are not necessarily qualified to do so.

17. See British Standards online.

18. Brigitte Borja, 2002 and 2004.

19. The ISO implementation project carried out by the Spanish State Agency for the Promotion of Innovation and Design (ddi) was fully documented, and information on the design practices that successfully participated in the project can be obtained from the organization. See ddi online.

V

Organizing design
in a company

There is no one rule dictating how to organize the design function in a company. Every model will vary depending on the company's particular line of business and its individual corporate culture. Globalization, at times a threat, also offers companies a world of potential resources for implementing and getting the best out of their internal design management.

THE STRUCTURE OF THE DESIGN FUNCTION IN A COMPANY

Not every company has a separate department responsible for its design projects. Nor does every company need one. The volume and level of organization it takes to run a large, multinational prêt-à-porter firm is very different from the needs of a local fashion boutique. The difference is not necessarily in how they understand design or its role in their strategic planning. However, whereas the multinational probably has the resources to mount its own, fully staffed design research centre and work together with the biggest names in the industry, the boutique will probably need a window dresser on a periodic basis only and will more than likely only hire a graphic designer sporadically to deal with the occasional event (e.g., its semi-annual sale). If the boutique grows and develops its own ready-to-wear line, it will need to draw on more resources and, vice versa, if the multinational decides to sell off one of its business units, that unit's design will go along with it.

VERTICAL INTEGRATION

One of the major decisions a company must make is whether or not to have its own design staff. There is no set answer to this question. In sheer economic terms, it makes sense to think about creating a new position when the expense of outsourcing a designer becomes more than the cost of a salary. However, the reality is not so clear-cut. There may not be enough (physical) room in the company to bring on an in-house designer. The company might not find anyone who meets the job description or matches its corporate culture. There might be concerns about

payroll increases. And most importantly, the company may not want to switch designers. Nowadays, some design studios are offering a service that was once the hallmark of large engineering consultancies: single-client designers who work on site at their client's facility, adapt their working hours and adopt much of the client's corporate culture, all while remaining employees of the design firm. This arrangement offers pros and cons for both parties. The client gains a more and better dedicated designer but loses the sense of contact with the studio owner (who is the person they are really hiring). The design company increases its work flow by having someone on site at the customer but also loses a person at the studio who could work on other projects.

Other designers offer agreements similar to the retainer fees once charged by doctors. In this arrangement, the customer pays a standard monthly fee in return for the guaranteed availability of the designer. On the one hand, this formula is comfortable for companies, because they do not have to worry about asking for whatever they need, and the designer benefits from a fixed monthly income. Still, at some time or another, both parties will probably start to wondering if one of them is getting the short end of the stick.

Hiring external designers to meet the needs of individual projects entails benefits like flexibility, variety, innovation and fresh perspectives. However, the process of bringing new designers up to speed for every project is also time consuming and laborious. In the end, those designers are consultants, and as a general rule, the relationship between companies and their consultants is a close one requiring considerable amounts of trust. Sometimes companies feel uncomfortable sharing intimate details with people, who, in the end, are outsiders.

Another alternative is to outsource design but always turn back to the same designer. When all is said and done, a designer needs to be an associate of sorts, and it is difficult to build a relationship of trust when there are frequent changes.

When the time comes, it should not be very difficult for a company to carry out a SWOT analysis[20] to assess the various possibilities and organization of is design services. Brigitte Borja and Kathryn Best are good sources with an ample information on the alternatives available.

LOCATION
The issue of location involves more than where the design services are physically located in a company, be it together, separate, in offices, or even with production. In the present-day economy, companies can also decide to offshore their design services, much as many have already done with their production business.

The idea of transferring one's design capacity to another company in a far-off land comes with its own distinct set of pros and cons. One important advantage may be lower costs. However, losing direct control over design also poses a major disadvantage and can even jeopardize the very essence of a company. In recent years, many companies have moved part of their production offshore to countries like India, China and others. At the same time, the design competence of these countries has increased considerably, and they now possess very skilled professionals. Before making the decision to offshore, companies will have to decide whether it is in their best interest to have their design services so far away, in a place with a different language and widely divergent visual and cultural codes. Some offshore companies have Western

designers on staff to supervise the work, while others only outsource the final stages of their design projects.

SCOPE AND SCALE

I have already discussed the notion that design is global and that as things currently stand, one multidisciplinary studio can handle all of a company's design needs. This being said, the same may not be entirely true for smaller companies. First, no small company can reasonably be expected to defray the cost of a team of such characteristics. Second, regardless of its particular strategy, if a company tends to invest more in one discipline than other, it only makes sense that it should choose of team with that speciality.

Finally, it is not a good idea to ask a team specializing in product or interiors to design packaging or prepare a communications project—or vice versa. They may not have the necessary knowledge or skills. If you do decide to have a design team work outside of its specialization, it should only be after a thorough analysis of the possibilities, conversations with specialists and an in-depth examination of their work.

When it comes to design services, it is important to keep in mind that it is a specialization that has appeared recently and that special training is required. In other words, particular care is required when contracting such services.

Anyone who is familiar with value chain analysis may have noticed that I have taken a similar approach all throughout this chapter. That is to say, by accepting design as one of the links on a company value chain, I have analysed how companies can add value through:

- Vertical integration.
- Location.
- Scope and scale of application.

There are also other concepts out there that can be used to add value and implemented for the better of design.

By this line of reasoning, the next step is to analyze the resources to use and determine how and to what extent they add value. This will be the topic of the next chapter.

20. A SWOT analysis is a systematic look at a company's strengths, weaknesses, opportunities and threats involved in a particular business context or situation.

VI

The resources required
for design

Companies that consider design a strategic resource will freely accord it all the value they place on their own corporate identity. They will also give it the resources it needs to guarantee quality that is comparable to the quality of the company itself.

People and equipment are the resources needed to carry out any business function in an organization. Design has a number of characteristic features that should be taken into account when providing these resources.

DESIGN MANAGEMENT

Design managers, as they are known in the industry, have special training that combines aspects of both management and design. As a specific discipline, Design Management has been quick to develop in English-speaking countries and is slowly taking root in other parts of the world. Now, there are field-specific courses, design management institutes and a whole range of specialized literature on the topic.

Design managers typically get their start in management or design and later go through specialized training to gain a working knowledge of the other discipline. There is no need for them to fully master both fields. The important thing for a design manager is to have strong grasp on the ins and outs of the other field and be fluent enough in its vocabulary to negotiate on behalf of both sides, comprehend where each is coming from and be able to speak in a language each will understand.

The tasks of a design manager include defining a design policy, organizing the design department, auditing products or the designers chosen to work on a project, assessing the outcomes of a project, etc.—in short, everything but the act of designing.

Some design managers may be company employees (e.g., in large companies with a strong commitment to design); others may be outside consultants. However, regardless of his or her particular status in the company, the design manager is the person who facilitates the dialogue between design and management in order to help the company draw on the full potential of design.

DESIGNERS

Selecting designers is no easy task. The process takes at least the same amount of time and dedication that is needed to fill any other important position in a company. Even so, many human resource departments are ill-prepared to deal with the creative professions and make design-related decisions.

Choosing a designer is simple for those who think design is about personal tastes. In such cases, it usually takes little more than a personal contact or a recommendation from a trusted friend or colleague. However, the decision becomes appreciably more complex and acquires new dimensions of responsibility in companies that think of design as the strategic function I have described in earlier chapters.

There are not many businesses in the market (at least in Spain) that specialize in the selection of creative personnel. Some design centres[21] may offer it as a service, but these are usually few and far between. Those that do typically base their endorsements on a group of designers whom they have previously identified — whether because they have reviewed their work, because the centre has comparable tastes and interests, because the designers regularly take part in centre activities, etc. — and tend to recommend those they trust more. This is not necessarily a bad thing, but it can be limiting. Some professional associations of designers may also be willing to provide recommendations; however, they will invariably recommend their own members, effectively passing up any other professional designers that might meet the desired profile.

If companies decide to rule out personal and institutional recommendations as a technique for selecting designers, they

must turn to the tried-and-tested selection processes that are used to cover other positions in the company.

The criteria that should be taken into account when selecting a designer are not very different from those that companies use to evaluate any other employee who will be in charge of a sensitive, high-responsibility task or area of the firm. Most importantly, the person in question should inspire trust and confidence. Personality is also a factor to take into account, since the designer should be able to get along with the people he or she will be working under. Companies also need to assess whether the designer has the technical skills and training need to carry out the required tasks.

When looking to hire an in-house designer, companies should make sure that the person selected can adapt to its corporate culture and will not clash with its work style and processes. In this case, the designer in question should have enough experience for the position that he or she will occupy, but this typically has more to do with his or her decision-making skills than any specific design-related training.

In addition to all of the above, companies that would like to outsource their design — regardless of whether they are interested in a long term collaboration or would rather work on project-to-project basis — need to make sure that the cost of the designer do not overly limit their potential outcomes. There are many professionals out there, and good ones at that. High fees are never a guarantee of the best possible result. Moreover, it is important to make sure that the team is available to do the job by the required deadline. If the desired design company works with a broad client base or is currently working on a large project (which could potentially

involve the whole studio), a client may be better off going to another designer unless it needs to go for that particular name for marketing reasons.

Because there is so much uncertainty when it comes to selecting a designer, many organizations like to host design contests as a way to resolve specific projects that come up. In most cases, this is a terrible idea as I discuss in more detail in Appendix 2.

Another simplification is to turn to fashion designers for all one's design needs. For many years (at least in Spain), the lay public has tended to equate design with fashion design, whereas designers are inclined to see it as anything but fashion. It is high time that someone correct this misconception. Fashion design is nothing more than design applied to a product, in this case apparel, with all the peculiarities that characterize fashion as a system. Other product-specific applications of design include workwear design, which covers everything from basic uniforms to the technology-laden suits worn by the fire brigade. If fashion design is product design, there is no reason that its principles cannot be applied to other types of products. The most important thing is for the company to hire a studio that is professional and has the skills it needs to carry out the specifics of the project at hand. Hiring a designer with a world-renowned fashion label is no ready guarantee of quality in graphic or interior design projects, for instance. <u>It is important to get good advice and have a good project management team in place.</u>

THE COST OF DESIGN

One of the chapters in any design budget, of course, addresses designer fees. Design projects are so varied and the agreements between companies and designers so personal that it is hard to synthesize them down into a defined set of standard industry rates.

DESIGN FEES
Companies in Germany can calculate graphic design fees using a practical online tool developed by the Association of German Graphic Designers (BDG) known as the "BDG-Honorarrechner online",[22] which calculates the cost of a project from a few basic variables (type of project, difficulty, size of the company, size of the project and the time available). In the United Kingdom, the design magazine *Design Week*[23] periodically conducts surveys to monitor year-to-year developments in the average industry rates.

In Spain, there are a few basic references published by the Designers' Association of the Community of Valencia (ADCV) and the La Rioja Design Centre (ADER) that provide of bit of orientation based on information collected from the market, but these sources are not updated with any regular frequency.

Companies will always be able to find someone who is willing to work for less money. The Internet is brimming with ready-made logos, and since the design profession is accompanied by a certain degree of prestige, the market is literally abounding with designers. In this scenario, it makes sense that younger designers will do whatever it takes to secure a customer base and that established suppliers will readily accede to customers' demands to secure their loyalty. Generally speaking, it is not a good idea to outsource design on the basis of price, unless, of course, the company considers it a mere exercise in styling, in which case, it should by all means do anything to cut back the cost. If a company's idea of design is putting a decorative bow on the final product, anything goes.

> COMPANIES THAT CONSIDER DESIGN A STRATEGIC RESOURCE WILL ACCORD IT ALL THE VALUE THEY PLACE ON THEIR OWN UNIQUE CORPORATE IDENTITY.

A good way of guaranteeing quality design that is at least comparable to a company's internal definition of quality is to prioritize key aspects like the customer-supplier relationship, the designer's experience, the implication of his or her staff, the level and extent of his or her international contacts, his or her system of "market intelligence", etc. One way to fetch better prices is to change suppliers frequently. The excitement (or necessity) of snaring a new customer often translates into a more favourable price. Nevertheless, as a general rule, I would not recommend "studio hopping" to companies that would like to maintain a coherent design throughout their communication and product line as a way of ensuring consumer recognition and notoriety

in the market. The exact opposite technique, i.e., always falling back on the same designer, can also be a way to obtain advantageous prices. The idea here is that the designer may not revise his or her rates on a regular basis and may offer special rates or added extras for very loyal customers. Even so, companies may not want to stick with the same team of designers for all of their design projects; they could end up with a monotonous repetition of the same visual codes, and the lack of surprise could make them virtually invisible to customers. Ultimately, the decision on the most efficient way to mete out the design budget and allocate design projects is up to the company design manager.

At any rate, companies should keep in mind that designer fees are invariably a small portion of the cost of a design project, an issue I will address in the project management section.

THE MATERIAL RESOURCES FOR DESIGN

Once a company has defined and hired its design team, the next step is to give it the material resources it needs to do its job. This comment may seem superfluous, but far too often, organizations fail to understand the needs of design. Also, the tools used by the in-house design staff may prove useful to the rest of the company.

One example of such resources concerns work spaces. Designers tend to work more productively as a team, meaning it is better to give them open work spaces with work stations that can be set up in a variety of different ways. They should also have a large surface where they can make concept maps, draw, hang up mood boards, post clippings from newspapers, notes, drawings, etc. Additionally, the company should encourage the construction of models and prototypes. In his famous book *The Art of Innovation*,[24] author and innovator Tom Kelley talks about the importance of employing models and prototypes from the very beginning of a project and using them to communicate with customers and fine-tune the product. I advocate the same prototyping for communication that Kelley recommends for product development. I think that it is easier to understand an editorial design with a model in hand (e.g., a cardboard box the size of the book with sketches for the covers). The same goes for a corporate identity or a website that has to get up and running as quickly as possible, or most any other project for that matter. If a company has the right facilities, the cost of "dirty prototyping" is fairly insignificant. Even so, it can substantially change the rest of a project. With this in mind, the design area should have the conditions needed for designers to work with their hands, build objects and play around with them.

THE PRECONCEIVED NOTION OF DESIGNERS WORKING LATE INTO THE NIGHT IN CHAOTIC SURROUNDINGS IS A HACKNEYED CLICHÉ. MANY DESIGNERS ARE HIGHLY ORGANIZED AND VERY METICULOUS ABOUT THEIR SCHEDULE AND ORGANIZATION AT WORK.

Others, however, are not so conscious, and it is up to the organization whether to give them more or less wiggle room. This said, no company can expect a designer to sit at his or her computer for eight hours a day and calmly come up with new ideas. Designers do more than just devise ways to visually represent concepts. Their actual work begins much earlier as they first start to conceptualize the object. In order to successfully carry out this preliminary phase, designers must take in information and have time to cross-reference it, debate it and test it out. One convenient method is by going to trade fairs to see what is out in the market. Here, the designer should not be restricted to trade fairs in the same industry, which are often — consciously and unconsciously — a breeding ground for copies. Many years ago, automobile manufacturers began attending textile shows to sniff out the latest trends in the fashion industry and reflect them in the bodies and interiors of their cars as a way of drawing in consumers. Similarly, a designer specialising in services might be well advised to cultivate an interested in technology shows, and an interior designer could find valuable input at a food fair. They need to know what users and consumers will ultimately use in order to develop something that users will find attractive and appropriate. Also, just as other departments check the Official State Gazette, are subscribed

to stock market newsletters and advisory services, or attend courses on logistics, the design department thrives on trend magazines, design books and face-to-face meetings with professionals from a variety of industries.

The important outtake here is that design, by nature, is an all encompassing discipline that has to drink from a variety of different sources. When a designer is flipping through the pages of a magazine, he or she is not wasting time. Routines and standing still are the worst enemies of creativity.

21. In Spain, design centres are generally official, public funded centres dedicated to the promotion of design.
22. See Bund Deutscher Graphik-Designer online.
23. See Design Week online (Salary Survey).
24. Tom Kelley, 2001.

VII

The design brief

When the design function is firmly in place in a company, its design management can get started with the projects that arise in response to its corporate design policy. One tool that is helpful when carrying out design projects is the design brief. Design briefs decrease the number of undefined variables, reducing the overall risk of a project, and provide criteria for assessing the outcomes of the resulting design.

THE DESIGN BRIEF

The word "brief" refers to a set of instructions given to a person about a job or task. In the worlds of design and advertising, the term has come to designate the written document containing the description and instructions for a project, and now, in one form or another (some languages prefer the gerund form "briefing"), the word has gained currency all throughout the world.

Design briefs contain all of the useful specifications that professional designers need to carry out a project according to their clients' particular demands. Every organization has its own model, but there are some common guidelines related to briefs that companies should follow. One important thing to keep in mind is that a brief is a *working* document between a customer and a designer. Fine-tuning it should be a joint effort, and it is important for both parties to agree in order to make sure that they are working on the same page.

The contents of a standard brief can be found in many different manuals. I personally recommend two sources: (1) the definition described by Lavernia at IMPIVAdisseny[25] and (2) the model proposed by Kathryn Best in her book *Design Management*.[26]

Nowadays, the very concept of a design brief has become controversial, and people not only argue about their format, but about whether briefs should be used at all. In the *Design Dictionary*,[27] Erlhoff and Marshall contend that the "[...] practitioners of design are becoming more aware of both the growing need for and potential benefits of so-called 'blue-sky' project for which, by definition, no briefs are prepared".

Once again, it is useful to keep in mind that there are benefits to experience and method. A designer with lots of experience or a designer that has been working for the same customer for years will probably only need a few basic instructions—but for everyone else, that is not enough.

Even though I am totally in favour of open projects, I have concrete reasons for insisting on a design brief. It is not only an excellent road map for the project. The act of producing a black-on-white definition of the project and its conditions also helps companies perform other meaningful functions as part of their design management processes:

- Determining an exact budget for the project.
- Providing guidelines for assessing the results.
- Smoothing out differences that could arise regarding the scope of the project.
- Transferring information to other people who join the team over the course of the project.
- Preparing reports and presentations to "sell" the project internally (e.g., serving as a good future reference).
- In short, the brief reduces the overall risk of a project by decreasing the number of undefined variables.

The frequent emphasis on briefs in design textbooks and schools is based on the fact that they are often written incorrectly and that many people do not make use of their full potential. A typical scenario goes something like this:

1. The company calls the designer, and by way of brief, they explain what they want, usually starting out at the end: "I want such and such a product" or "I need it to look like such and such."

2. If the designer wants to do a good job, he or she has to steer the conversation to find out the problem that the company would like to solve and use it to debrief the client with the relevant questions, without proposing any solutions.

3. The company will have to validate the questions and set the conditions and limitations of the project (e.g., time, budget, if the project is limited to a particular production unit, material(s) or technology, etc.).

4. The designer will then propose a "design plan" or the conditions for carrying out the project, which must be accepted by the company.

5. More often than not, the project will start right away on the basis of a tacit agreement due to time restraints; this can cause misunderstandings and disagreements. That is why it is important to spend enough time on what Hollins and Hollins refer to as "front-end loading".[28] The time spent preparing a project is not time wasted; the more time that is spent up front defining the concept, the less will be needed to actually develop it.

Among the other conditions and specifications, a design brief may also contain penalties or provisos that apply if one of the parties fails to meet the project deadlines. For example, a project could be delayed if the customer does not provide the relevant information on time. In this case, the penalties for unmet deadlines should be made conditional on the timely delivery of information. Similarly, the brief should state the consequences if a designer fails to meet his or her submission deadlines. As a customer, if I order a set of brochures for a trade fair, I need to specify that after a certain date, I will no longer accept them and will not pay for any work that has been done on them. However, if the designer was unable to finish the project on time because I did not submit the required corrections, he or she will be fully entitled to bill the project, even though the material was never printed. Or not. It all depends on the agreements reached by the parties at the beginning of the project. In the day-to-day reality of the industry, things usually go so fast that the rules are set tacitly, and problems are usually resolved with an ample dose of common sense, good faith and standard industry practices. In the event of problems, associations of designers can appoint an expert to arbitrate on the issue. When disputes make their way into the court system, judges will sometimes call for an expert on the matter to provide professional testimony as part of the judicial proceedings.

If a brief reaches this level of detail and specifies the conditions so meticulously, Peter Phillips[29] suggests using it as the contract or as an appendix to the contract. However, according to Best,[30] if the brief stands in for a contract, "it is important that the client is involved and updated at all stages, and that the design team regularly revisit the agreement and

obtain client sign-off if any changes do occur". Many designers still work without a contract. This practice is complicated and dangerous for designers and their customers, because both parties are left without the protection of a legally binding document and because uncertainty is a frequent source of confusion and dissatisfaction. When no contract is used, it may be a good idea to replace it with a well-written brief.

If briefs are so important and there are many companies that do not work with them or do not write them well, then why don't you hear about more problems and mistakes? The truth of the matter is that there are mistakes, lots of them, but people tend to keep mum on the topic. We all like to share our successes, big and small, but it is hard to find someone who wants to take part in a design conference and talk about their own personal horror story.

> MUCH IN THE SAME WAY THAT A DESIGNER'S EXPERIENCE CAN MAKE UP FOR THE LACK OF A DETAILED BRIEF, TO A CERTAIN EXTENT, THE COMMON SENSE OF CUSTOMERS AND THE EXPERIENCE OF THEIR STAFF CAN BE THE SAVING GRACE FOR A PROJECT.

Some of a project's best allies are the technical office that corrects the work of young designers, the printer that reminds the graphic designer of the tricks of the trade, the "Mr Fixit" who resolves all the unconsidered issues when setting up an exhibition, or the suppliers who suggest alternative uses for their materials; these people and others like them are often directly responsible for the success of a project. That is why it is easier to work in a good design cluster, with a range of knowledgeable suppliers. For this same reason, it is also

important for designers to cultivate a well-rounded support network to assist them in their work.

TODAY'S WORLD IS COMPLICATED, AND NO ONE SINGLE PERSON CAN KEEP UP TO DATE ON EVERYTHING THERE IS TO KNOW. SPECIALIZATION IS THE ORDER OF THE DAY, AND NETWORKS WOVEN BETWEEN SPECIALISTS ARE THE TOOLS THAT GIVE THIS SORT OF MARKET THE SENSE AND EFFICIENCY IT NEEDS TO BE PRODUCTIVE.

25. I particularly like the structure of the brief proposed by Nacho Lavernia on the IMPIVAdisseny website (available only in Spanish and Valencian). It is both balanced and useful, and it is plain to see that he has perfected it over years of use.
26. Kathryn Best, 2007: Conceptually speaking, her description of a design brief is immaculate.
27. Erlhoff, M. and Marshall, T. (Eds.), 2008, p. 58.
28. Hollins and Hollins, 1999.
29. Peter Phillips, 2004.
30. Kathryn Best, 2007, p. 94.

VIII

The design project

Proper investment at the beginning of a project guarantees less development time and greater control over the related expenses.

WHAT PROJECTS SHOULD A COMPANY DO?

Decisions regarding the projects a company should undertake are the responsibility of its design management staff, guided by the corporate design policy, in collaboration with marketing and the firm's other functional areas. This is a good moment to think back to the discussion in chapter 3 on "design intelligence" as a way of gaining a better understanding of the market and identifying potential opportunities.

In the trade, there are also tools known familiarly as "design audits", which are especially designed to analyse the situation in an orderly fashion and determine the logical next steps for a brand or product. Some of these tools can be used by a company's own staff, though there are also professional consultants who specialize in their use. The advantage of working with outside consultants is that they can help companies examine their product in a more critical light and may propose improvements that would never have occurred to someone in the organization.

Marketing is a key component of design audits, since products do not exist in a vacuum, but are positioned competitively in the market against other products. They also include considerations on the end user of the product (e.g., how and what does the consumer expect of the product?). Finally, a good audit should take into account the physical (related to the production team) and financial possibilities and limitations of the company at hand.

IT GOES WITHOUT SAYING THAT A PROPER AUDIT WILL ALSO ADDRESS THE GLOBAL NATURE OF THE "VISIBILITY VECTORS" AND NOT JUST THE SPECIFIC PRODUCT, SERVICE, SPACE OR COMMUNICATIVE NEED:

Products are not sold strictly as they are; they come in a package, are advertised, and are launched in a particular location. All aspects of a product contribute to its success, and isolating just one feature or another is risky business. For this very reason, designers belonging to a particular speciality are not the individuals most suited to carry out a design audit. For instance, an industrial designer will have an easier time evaluating a product, whereas a graphic designer would be better at assessing a communication project. Someone giving a catty interpretation might say that they would recommend their particular specialization to drum up business, but this is not the crux of the matter. Their specialization works like glasses that cause them to see the things they know, and as a result, they naturally pay more attention to problems they can solve, albeit unconsciously.

At any rate, there are a number of different design audit models available that have been developed by independent consultants, design promotion centres and other related organizations.[31]

MONITORING THE PROJECT

Here, I do not want to discuss the day-to-day management of the project. In small companies, this is something that will be done informally as the project progresses and will not be the subject of unduly formal administrative procedures. Certified companies will follow the established protocols. This said, there are three points I would like to address on this issue:

ONE
The significance of the research phase in the project's end result. Just was the case with the design brief, the more that is invested at the beginning of a project, the faster it will progress later on. Design has its own research methods, which focus primarily on trying to understand how objects (including two and three-dimensional objects and virtual spaces) are used, and, as I have already touched on before, it has adopted methodologies from other fields to document and interpret how people live and relate to the things around them. Documentation processes have also found a place in marketing, a discipline that has often been accused of basing its conclusions on past events (market studies, surveys, etc.) that only provide information on things that are already known (since researchers cannot investigate an experience that does not yet exist). Advances in user studies or user-centred design, of which IDEO[32] was a pioneer, offer a much more intuitive — and by extension, informal — perspective and prove advantageous as an early way of detecting what users will be asking for tomorrow. User studies are a far cry from mere hunches or flashes of inspiration; rather, they employ techniques that yield relevant conclusions in a very

short amount of time, giving companies enormous advantages in time to market, fostering opportunities and a potential edge over their competitors. It is pointless to discuss whether user studies originated in marketing or design. Ultimately, they arose from the need to be the first one to bring out a radically new product designed with the needs of users in mind. The techniques used in these studies may seem extravagant to someone who is attending for the first time, but they have been in use for quite some time, and a string of success stories is a testament to their effectiveness.

TWO
The possibility of discontinuing a project before it is complete. Hollins and Hollins[34] recommend that over the span of a project, designers and companies should frequently reassess what is currently being done against the initial goals, double-check that there are sufficient funds to finish the project, keep an eye on developments in the market while entrenched in their work, and repeatedly ask themselves if the time has come to abandon the project. This reasoning is especially valid for projects that are long in the works, as is frequently the case with objects and also with websites, which are becoming more and more intricate and require increasingly more dedication. At any rate, it is important for those involved in a project to identify the "point of no return" as well as the point when continuing on with the project will be more expensive and cause more headaches than simply calling it quits.

THREE

The importance of documenting the process. This may seem tedious, but at bare minimum, every design project should include at least the following three documents:

- A time line showing the stages of the project and the various meetings and deadlines.
- An outline of main points of each of the meetings.
- A memorandum recording any issues dealt with on the telephone. The decisions should be documented in an e-mail, for instance, and CCed to the relevant parties.

Documenting the process is bothersome, and no one likes doing it. Projects usually start out well, but somewhere along the way, people seem to forget that they had to write everything down. The project leader has all of the information in his or her head and uses it to guide the process as time and memory permit. This system is inherently dangerous, because all of the information will be lost if, for whatever reason, that person suddenly ceases to be involved in the project. It is also a problem when someone new is brought on the team as a replacement or reinforcement. Due to the lack of written information, the rest of the team will have to transmit their knowledge orally, and valuable time will be spent bringing him or her up to speed. Moreover, the process of documentation is especially important for consultants. If they do not document their steps and limit themselves to a final report, their work risks coming across as trivial and insignificant.

DOCUMENTING THE PROCESS

ANOTHER EXAMPLE: If a graphic designer is asked to design a corporate image and the only thing he or she submits is the printed stationery, it will look like like the print shop did all the work. On the contrary, by documenting the process, he or she will ultimately deliver one or more folders containing:

- The project brief.
- The documentation gathered for the brief: colour studies, typographic studies, examples, etc.
- Memoranda of the meetings.
- The first proposals, which were used as a basis for further development.
- Colour composites, sample materials, etc.
- The corporate style guide.
- The corresponding computer files.

All in all, this is a good "chunk" of information. Not only does it take up space on a customer's shelves, the company can also refer back to it at any time to revisit any previously discarded ideas, identify a decision-making process that it would like to duplicate, etc.

INVESTING IN THE EARLY STAGES OF A PROJECT: FRONT-END LOADING

In a study from 1997,[34] John Thackara included an interesting chart (see below) that I would like to interpret here.

The impact of design on the total cost of the project

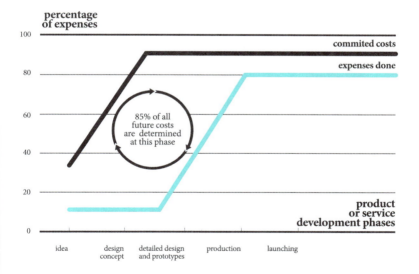

Precluding any discussion of the accuracy of the scale and quantities used, the chart offers an interesting revelation:

THE COSTS INCURRED AT THE BEGINNING OF A PROJECT WHEN DEVELOPING THE IDEA, REPRESENT A RELATIVELY INSIGNIFICANT PORTION OF THE TOTAL COSTS. THE KEY POINT TO KEEP IN MIND HERE IS THAT THESE COSTS, WHICH ARE ALMOST IRRELEVANT IN LARGE-SCALE PROJECTS, ARE WHAT CONDITION THE REMAINDER OF THE PROJECT. THAT IS WHY THE DECISIONS MADE DURING THIS PHASE OF THE PROJECT ARE SO UTTERLY IMPORTANT.

At the end of the day, the difference in fees between one designer and the next will not be all that significant, even if one has considerably more experience than the other. The difference in costs incurred over the life of the project, however, can be colossal.

Everyone makes mistakes, and there is not one design team — or any other team for that matter — that can claim it has never slipped up at one time or another. That said, the more professional and experienced the team, the less errors it is likely to commit. And the cost of fixing a blunder rises exponentially over the life of a project. A report by the Design Council suggests that for every $10 spent to fix a problem during the project design phase, up to $100 are spent to fix the same problem at the time of the product launch.

This effect is clearly visible in the chart.

Costs and possibilities of introducing changes alongside product development process

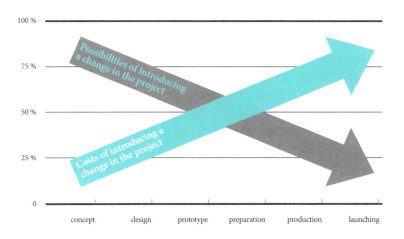

Also, the better a design team's information system, the less likely it is to develop something that could be considered a copy. The market is fully of unfortunately similar designs. *CoCos, Copies and Coincidences,*[35] a 2003 exhibition in Spain, showed how the information that flows through the market can result in coincidences, but it is important to make sure a lack of imagination or information is so not great that it gets the team embroiled in a situation with legal consequences.

The more experienced a team, the fewer mistakes it will make in the brief and the fewer the surprises that will crop up along the way. A good example is web design in the early days of the Internet. The only thing designers budgeted for was design hours and programming, and it did not even occur to many designers, or to myself, to talk to clients about the cost of *maintaining* the website. However, as time went along, they (we) learned to reduce the programming complexity and discovered that the lion's share of the budget is eaten up in maintenance.

Ah, and just to be clear, I'm talking about experience, not age.

31. The Design and Manufacturing Institute (see Instituto de Diseño y Fabricación online), an affiliate of the Polytechnic University of Valencia, offers design audit and opportunity-identification services to those looking to develop new products and services.

32. IDEO is an innovation and design service company founded in Palo Alto, California. See IDEO online.

33. Hollins and Hollins, 1999.

34. John Thackara, 1997.

35. Capella and Úbeda, 2003.

IX

Evaluating design

Design is risk, and businesses must learn to manage it. The good news is that design is profitable, in terms of both ROEx and ROI.

TO MEASURE OR NOT TO MEASURE? WHAT TO MEASURE AND HOW TO MEASURE IT?

Much as with the controversy over design briefs, which I touched on momentarily in chapter 7, the industry is also divided when it comes to the need to assess the profitability of design. Some designers argue that the discipline should prove its worth in terms of concrete measurements. Champions for the other side contend that they should never have to justify anything, because design is a question of conviction, not of reason.

If you ask me, the whole discussion is moot, because there will always be specific moments or situations where designers will have to demonstrate something concrete, even if only to decide whether to move forward with a project or abandon it. There will also be times when there is no need to justify a project and cases where reducing the aspirational nature of a project to basic accounting variables could risk corrupting the whole endeavour.

The discipline of design management is resolving the issue of measurements very slowly. Assessing intangibles is at best a difficult task, and the discipline is still in its infancy. Part of the difficulty is that it is hard to come up with a formal definition of something intangible, and part involves the complexity of working such aspects into formal accounting systems, which —much like many of the management models currently in use— have become hopelessly obsolete: it seems utterly paradoxical that knowledge is a firm's greatest asset but is not recorded in the books as part of its capital, i.e., the wealth, of the company. That being said, I will leave the issue of developing formal techniques

for analysing design in strict accounting or financial terms up to other experts[36] or at least to another, more appropriate text.

At any rate, what exactly should designers evaluate and why? There is a widespread belief that quantifying design's impact on corporate balance sheets will benefit its cause by offering companies a rational decision-making tool. Designers who uphold this point of view argue that numbers are the only basis for a valid argument in the business world and ergo the only way to sell design adequately in corporate circles. Such reasoning, however, ignores among other things the fact that marketing has not had to resort to figure-based arguments to defend itself and is still considered to be an essential component of any company.

In my opinion, it is ultimately a market issue. Back when companies knew how to manufacture quality products but did not know how to reach the market, they naturally turned to marketing. Nowadays, they know how to manufacture and persuade customers. The new challenge resides in increasing the usability of products, so that customers prefer them, no matter where they are in the world or what references they have at their disposal. Sometimes, this usability will translate into price or unique product features. Other times, it will be the brand values imbued in the product or the brand's social values that prevail. In any case, design is what allows products to develop in terms of these values and features and what makes them visible to consumers.

INDUSTRY IS GRADUALLY AND NATURALLY EMBRACING DESIGN AS A MANAGEMENT TOOL, BECAUSE IT NEEDS THE RESOURCES DESIGN HAS TO OFFER AND BECAUSE IT HAS NO MORE EFFICIENT WAY OF CONCEIVING GOODS AND SERVICES THAT SATISFY PRESENT-DAY CONSUMER DEMAND.

Even so, it is important to keep on trying to evaluate design, if but to have an efficient decision-making tool on hand. So much of design is subjective that it would not hurt to incorporate a bit of rationality.

THE FIRST DESIGN MEASUREMENT: ROEx[37]

I propose that the first major design measurement should be the <u>Return on Expectations</u>, or ROEx. This is frequently used in the social sciences and to assess training programmes and was developed in response to the general dissatisfaction of users who tried to use the Return on Investment (ROI) model to measure the impact of intangible results.

WHEN APPLIED TO DESIGN, ROEx MEASURES THE INITIAL DEGREE OF INVESTOR SATISFACTION WITH THE END RESULT OF THE DESIGN PROJECT, BEFORE THEY SEE EXACTLY WHAT HAPPENS WHEN THE PRODUCT IS ACTUALLY LAUNCHED IN THE MARKET.

The underlying reasoning is that, as stated in other chapters, design:

- Needs the support and involvement of the CEO if it is to be implemented successfully.
- Has the power to radically transform an organization.

But for this to work, the CEO must be satisfied with the things design is doing and see that design has a thorough grasp on the company's strategic stance and is properly reflecting it in its work. His or her satisfaction is also what allows design to take full advantage of its management potential.

For instance, when a design director starts a planned project to revise a company's corporate identity, there are two distinct phases to the project:

- Presenting the new image to the CEO.

- Launching the new image.

When the new identity is first presented in the company, the CEO will have an immediate reaction on the basis of two factors:

1. Whether the image is applied well in the required pieces, whether it contains all of the required information and is organized in logical fashion, whether there are errors, the text is legible, the print quality (e.g., photography) meets expectations, etc. It is easy to come up with a list of items and check one by one to see if they are met. The degree of fulfilment could be 30%, 80% or 100%.

2. Whether the image lives up to his or her subjective expectations concerning its overall look, texture, weight, the feel of the different pieces, and whether he or she feels that they meet the defined objectives. Here, it is also possible to determine a list of points and evaluate them.

By extending this test to a select group of stakeholders, the design staff will have an indicator that can be used to assess the validity of design projects, compare the evolution of the work produced by the design department over time, and analyse the differences between the various projects and phases of the corporate design policy. When applied to a particular project, a dozen questionnaires can give the design staff a good indication of the organization's take on the result in question and some positive guidance for future improvement.

There is one thing to keep in mind with ROEx, however. It cannot be used to measure someone's prior expectations if there is no prior specification. In other words, companies should decide in advance if they want to use this type of measurement and take it into consideration when developing the corporate design policy or when starting a new project and writing up the project brief.

THE SECOND MEASUREMENT: THE ROI[38] OF DESIGN

Determining whether or not an investment was worthwhile in financial terms is, and has been, the classic research topic in design management. To answer the question, one has to determine the quantitative impact of an investment on the market.

The first thing to keep in mind is that organizations can measure specific tangible and intangible goals, such as:

- Increasing sales (with a new product).
- Increasing market share (with a new product line).
- Reducing costs (with a redesign).
- Reducing absenteeism (with new offices).
- Raising visibility (with a new corporate image).
- Winning design awards (with avant-garde design).
- Or any other reasonable example.

The difficult thing about such an assessment is determining the part that can be attributed to design and separating it from the rest, which is often intimately connected to the design. Take, for example, a company that has just undergone an extensive redesign and decides to prepare a new catalogue, where the product is easier to understand, the collection and prices are clearer and the information is faster and easier to find. The normal thing to do after making a new catalogue is to promote it in two directions: (1) to customers in the form of a special mailing and (2) to the sales force along with special training to explain the improvements. If the result is an increase in sales, which of the actions is responsible? The design? The promotion? The added motivation of the sales

force after the special training? The improved attitude of the sales staff, which finds it better and more motivating to work with a modern, easy-to-use tool? And if all of these play a role in the increased sales, what specific percentage of those sales can be attributed to the designer? Which part originates from the mere existence of a new catalogue, regardless of its design, and from the increased motivation of the company's employees? How much of the increase in motivation is due to the existence of a new catalogue? How should a company compare this against the hypothetical situation that would have resulted if they had not invested in designing a new catalogue? If that were not complicated enough, in the case of a redesign, a company can at least compare the new results with the former outcomes prior to the change; however, in the case of a new product, how can a company compare the result of the investment required to design a product against a situation where that product simply did or does not exist?

TRYING TO ANSWERS THESE QUESTIONS IS EXTREMELY COMPLICATED AND CUMBERSOME. MORE OFTEN THAN NOT, THE ROI OF AN ROI ASSESSMENT IS NEGATIVE, ESPECIALLY IN SMALL COMPANIES OR PROJECTS WITH A LIMITED SCOPE.

In fact, according to a study by the French Ministry of Economy and Finances,[39] companies usually engage in exhaustive attempts to calculate the ROI the first few times they flirt with design but soon start to lose interest in the process.

Even so, I would like to go still deeper in this discussion of the topic. There are two types of design ROI: direct ROI and indirect ROI.

DIRECT ROI
Several years back, professors Hertenstein and Platt from the Northeastern University in Boston developed a model that displays in graphic terms the tools that design uses to create value.[40] Inspired by that model, the following graphic in this chapter clearly demonstrates the value-generating potential of design on two fronts. On the one hand, it lowers expenses by improving processes, searching for new cost-saving materials or redesigning pieces to lower production costs. On the other hand, it affects the profitability of sales operations.

There are many ways that design can cut back on costs. Cost-saving redesigns might include redesigning a storage system to achieve the same result but using fewer materials; redesigning a book to make better use of paper; adapting a radiology unit to reduce errors in order to shorten the waiting list and diminish the number of tests that must be repeated; or using the design research techniques discussed earlier to cut down a product's time to market.

Conceptual mapping of a new product development

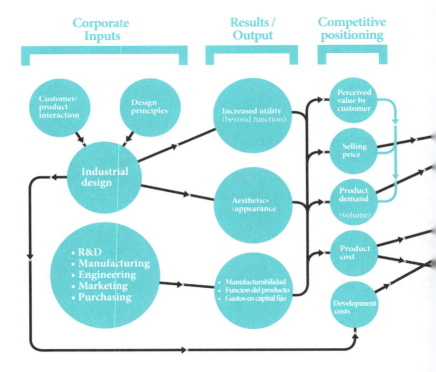

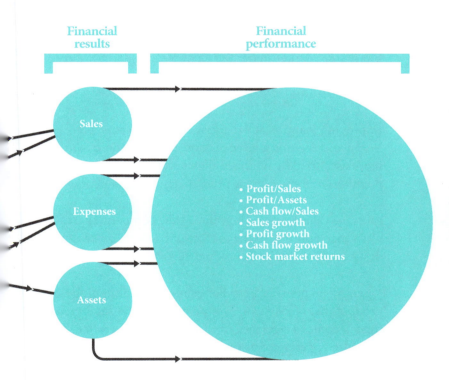

When I talk about enhanced earnings, I am referring to:

Increasing sales: Examples include redesigning product packaging to support a relaunch or designing a furniture catalogue that allows sellers to convince customers even if they do not have room to display the whole collection in the store.

Increasing market share: For example, designing a tool that resists extreme conditions and ends up displacing the competition.

Improving margins due to increased added value: For instance, designing a piece of consumer electronics with a more user-friendly interface allows companies to ask for a premium over the average price charged by competitors.

Increased share price: The value of the company shares often increases due to the market impact of a successful design that redefines its product category.

Opening up new markets: For example, by designing a product that is easy to use for people with a disability and then becomes a reference in the market for everyone else who also appreciates its ease of use (e.g., low-floor buses).

Opening up foreign markets: Be it on account of a design that is well adapted to uses in another country or an intuitive website design developed especially for e-commerce.

It is clear from these examples, that the success of these products is not the result of design alone: they also benefit from the influence of marketing, advertising, sales, the after-sales service, financing, quality, etc. This is precisely the difficulty. Is it possible then to accurately measure the return on a design investment?

To find out the answer, researchers would have to be able to do a laboratory test where they bring out two products at the same time in identical conditions, except that one has a design-related investment of *1* and the other an investment of *1+n*, and then measure the results mathematically. Some researchers have performed these types of studies with generally satisfactory results, but there is no way to obtain a measurement that is 100% accurate or standard across the board. That is to say, if the return on investment achieved by an automobile manufacturer is 1:5, would the return for a china tableware company also be 1:5? Or maybe it would be 1:100? In *Design Management*, Brigitte Borja thoroughly reviews all of the studies conducted to date but does not recommend one result over the others.

Andrew and Sirkin[41] have found that most innovative companies do not have precise systems in place to measure the profitability of their investments in innovation. Instead, they tend to accept more approximate indicators, such as:

- The percentage ratio of R&D to sales.
- The number of patents.
- The number of new products as a percentage of their total product portfolio.

The design equivalent would be:
- The ratio of design expenses to sales.
- The number of protected designs.
- And again, the number of new products launched versus the total number of products in the company portfolio.

Another measurement that is sometimes of interest is the payback time on the investment. As an indicator, payback time can be problematic, however, because the prevailing conditions in the market are always changing and no two situations are alike. This type of abstract economic analysis, replete with its famous restriction *caeteris paribus* (all things being equal), is not easy to carry out in real-life situations.

If a company would like to have a general idea of the return on a specific project, the important thing to do is set a clear and quantifiable goal at the outset. Such a goal might be:

- To increase sales by x% in x months.
- To increase market share by y% in y months.
- To reduce the cost for materials by z% in z months.

Finally, to calculate precisely whether the company has reached its goal, it is, of course, essential to conduct analytical or project accounting. If not, all other efforts will be in vain. In companies that do not use analytical accounting, the design director needs to prepare his or her system to record, albeit with recognizable limitations, the expenses and income related to each specific project.

INDIRECT ROI

Design also tends to yields a return in the form of greater appreciation for a product. This return entails improvements in the intangible concepts that have an indirect and long-term effect on quantitative measures, including:

<u>Brand notoriety:</u> due to differentiation of a company's products in the market.

<u>Customer satisfaction:</u> due to better product features.

<u>Employee satisfaction:</u> due to the improved image projected by the company (e.g., after a corporate identity redesign) or due to improved workplace conditions (e.g., after outfitting new offices or changing uniforms).

These variables can be measured using opinion surveys and market studies if an immediate response is necessary and feasible. In some cases, information on these factors can also be reached through "proxy variables", i.e., related variables that are not in themselves precisely what one wants to analyse. For instance, a company might measure the impact of an office redesign by assessing the variation in the number of incidences in the quality system or changes in employee absenteeism.

Nevertheless, in other cases, companies will have to wait for the equation to work itself out over time and reveal the improvements in their tangible results. The Design Council, carried out a highly interesting study on design and company share price, which ultimately uncovered that the companies that invested the most in design (those that, for the purposes of the research, comprised a so-called "design index") also

The impact of design on stock market performance

had the best stock market performance over the period.[42] The results of this study are shown here in a chart (see previous page) which speaks for itself.

A parallel study of Spanish companies and design conducted by ddi[43] in 2005 showed that the companies that were the best at managing their design were also those that grew the most.

These types of studies show that the direct and indirect ROI of design is positive. Even so, there is no magical equation that will show a company the exact return it should expect to crank out for every dollar spent on a designer. The issue is not that simple (or that interesting for that matter). As I have said before, there is good design and bad design. There are good businesses and bad businesses. There are stimulating relationships and relationships that result in disaster. Design is risk, and businesses must learn to manage it. The good news is that well-managed design is profitable, in terms of both ROEx and ROI.

FEEDBACK

Regardless of the result of a project, the important thing is that companies can use whatever they have learned to keep on improving. Design is not an occasional expense that can be forgotten once the invoice has been paid or the newspaper article hits the presses. Design is a function that companies must integrate in the organization if they want to improve their long and short-term results and processes. The benefits of design are also cumulative. When design is properly integrated, companies stand to gain:

A product that is well-conceived for its <u>use</u>, has an appropriate <u>price</u>, is packaged in a container that is sensible from the point of view of <u>logistics</u> and the <u>environment</u>, and is accompanied by communication that projects its <u>values</u> and promotes <u>visibility</u> in an environment that is <u>efficient</u> and pleasing to people, and all of this applied to the company's <u>entire range of products year after year</u>.

In the end, the market will perceive a sense of consistency in the company proposal, and consumers will prefer it because:

- They know it.
- They distinguish it.
- They appreciate it.
- They can trust it.

This is the moment when a company will realize the positive returns on all of its hard work and investment.

MEASURING THE ROEx AND ROI OF EVERY PROJECT GIVES A COMPANY USEFUL INFORMATION ON THE WHOLE OF ITS DESIGN POLICY AND CAN BE USED AS THE BASIS FOR FURTHER REFLECTION AND POTENTIAL CORRECTION, WHEN NECESSARY.

But for this to work, design has got to be systematic in getting the word out on these variables, especially since, as I discussed in the design policy section, they can be used to sell design internally and to manage a reputation in design.

Insofar as a designer's contribution is the product of close collaboration with other departments in the company, the results of his or her work must also be evaluated with that in mind, and any consequences, good and bad, must be examined in terms of joint responsibility. Aside from the occasional bad designer, many product failures are due more to the inexperience of the customer than a lack of knowledge on the part of the designer. Troubles related to formal problems, usability issues, excessive costs, etc. can frequently be traced back to businesses that insist on their personal tastes to the detriment of professional criteria (and the weakness of designers who are not capable of imposing their own views).

AT ANY RATE, IT IS IMPORTANT TO KEEP IN MIND THAT NO MATTER HOW GREAT THE RESULTS OF A PRODUCT, DESIGN ALONE IS NOT ENOUGH TO SAVE A COMPANY. THERE IS LITTLE A DESIGNER CAN DO IF THE OTHER FUNCTIONS ARE NOT MANAGED PROPERLY.

36. For example, Eusebi Nomen, 2005.

37. I suggest to use ROEx to avoid the confusion with ROE (Return On Equity).

38. Earlier, I mentioned the difficulties associated with costing design expenses. In the absence of specific data, I am using "Return on Investment" (ROI) liberally and refer to the most ordinary, informal meaning of the term.

39. Design France, 2002.

40. Hertenstein, J. et al., 2005.

41. Andrew and Sirkin, 2008.

42. "Design Index: The impact of design on Stock Market Performance - Report to December 2004". The study can be found on the Design Council website.

43. "El impacto económico del diseño en España", ddi, 2005.

X

The next step:
design thinking

The discipline's latest frontier is design-based management, whose goal is to improve innovation processes and tackle management issues with more effective resources than those proposed by the century-old theories prevalent in the discipline.

THE MANAGEMENT OF THE FUTURE

The problem with management models is, by and large, that more has changed that just the market; the very way that businesses are run is now different. In today's world, competition is cutthroat and pervasive, and it is getting more and more difficult to manage due to rapid developments in technology that keep the market in a constant state of flux. Barriers to entry are coming down in many industries, and market equilibria are continually being turned on their head. Nowadays, it seems there is an opportunity for anyone who knows how to capitalize on technology. According to Gary Hamel,[44] the market is giving way to new networks and systems over which organizations have little control, and competition is becoming less and less the result of a preeminent position in the market than the subtle art of negotiation to find opportunities. The Internet has empowered consumers, giving them access to a nearly perfect source of information in an economy where there is no room for mediocrity and where product life cycles are becoming shorter by the hour. Hamel contends that most present-day management theories are more than a hundred years old and were created for a world that no longer exists. His final assessment is rotund. To paraphrase Fukuyama: management is dead.

This may be an exaggeration, but the truth of the matter is that most preconceived notions of what it takes for a company to be successful are no longer valid. The market itself has seen to that. Linear thinking grounded in the principles economic rationality may be a useful point of departure, but no company should ever regard them as dogma.

In the face of this challenging reality, design has developed a new focus that may shed some light on the issue of management.

WHAT EXACTLY IS "DESIGN THINKING", ANYWAY?

In October 2005, SAP AG,[45] working collaboration with IDEO,[46] founded the Hasso Plattner Institute of Design (also known as the "d.school"[47]) in Stanford, California in order to train its staff on the techniques and processes of design. Procter & Gamble[48] has since joined the initiative,[49] and both companies are investing heavily to research and train employees in what they are calling "design thinking", or in other words, a way of thinking about management based on design.

So far, the world of management and the economy have largely ignored the concept. Designers, however, are taking it with a mixed sense of admiration and misgiving, and everyone is trying to lay down exactly just what design thinking is.

At design thinking conferences organized by designers, the term will most likely be used as a synonym for what is sometimes called "advanced design". In this context, presentations will generally concern service design, new and sophisticated interaction design or some of the challenging programs of social design. I do not wish to indulge in a polemic with designers, but if you ask me, this is all just design as usual, only applied to the challenges of today's market. Besides, it is reasonably obvious that designers apply design thinking to what they do—or do they?

Since its early days, design has gone from dealing with products (i.e., tangible goods) of greater or lesser complexity to a progressively increasing involvement first in product-service systems, then in services and lately in social systems. These are all territories that design has conquered, and in each, design has shown itself to be an extremely strong

performer. However, now, the next step lies in applying the design approach to management, to the management of businesses. This, to me, is what design thinking is about.

I first read about design thinking in an article by Prof. Brigitte Borja, describing her initial visit to the D-School in 2007[50] so in the article, she singled out the present-day conflicts faced by firms as new fields for design thinking, because the problem-solving framework employed by design is particularly well suited to such complex and unknown challenges.

At this point, we are now able to provide a description of that particular framework. To sum it up, the design mindset is all about:

- The ability to frame problems in terms of a project so that it can be defined from both a conceptual and a time perspective.
- The discipline of putting the user at the center of every project.
- A holistic vision that embraces a wide variety of viewpoints and information.
- The spirit of always going beyond the already known territories, trusting intuition.
- The ability to envision potential solutions with the help of scenarios and prototypes.
- The rigor of testing so as to validate one's intuition.
- The talent of explaining and communicating solutions with the help of visual narratives.

By applying the previous framework to the resolution of management issues, businesses will be able to embrace

In this regard, I agree with Prof. Roger L. Martin's line of thought when he says that design thinking helps strike a balance between analytical and intuitive decision-making processes.[51]

Proof that this can work can potentially be found in the success of so many small-scale design entrepreneurs who are able to shout out, "But of course! That's what I've been doing all along!" These are typically small manufacturing companies founded by designers or business people with a design mentality, and thanks to the intuition of their founders, most have managed to weather even the most trying of circumstances. Further evidence of this concept is also apparent in the very existence of the design service industry, which has matured, grown and created both wealth and jobs, all despite having little formal knowledge or training in management.

At any rate, this theory shows that design embodies the potential to benefit companies as a whole. That does not mean that every company has to be managed by a designer. Not all companies can, want or should even have to want to turn their operations over to someone from the design profession. The key thing here is for companies to learn from design, give it a bit of latitude in the organization and not just limit it to a mere utilitarian function. In a recent article, Tim Brown[52] said that "the former role [of design] was tactical and results in limited value creation; the latter is strategic and leads to dramatic new forms of value".

There is not much more to say about design thinking at the moment. It is a script in progress and sounds good so far, but only time will tell where it will end up. Regardless, I firmly believe that there must be a greater overlap between

but only time will tell where it will end up. Regardless, I firmly believe that there must be a greater overlap between design and management, a concept that the field of design management has been insisting on for quite some time.

44. Gary Hamel, 2007.

45. A company specialising in management software. See SAP AG online.

46. See IDEO online.

47. "d-school" stands for "design school" and is an allusion to the so-called "B-schools" or "business schools". See the Hasso Plattner Institute of Design online.

48. See Procter & Gamble online.

49. To find out more on this topic, I recommend an article by Brigitte Borja (2007), which discusses her experiences at the D-School campus, as well as Brigitte Borja, 2008

50. Brigitte Borja, 2007 and 2008.

51. At the moment of writing this text, some of the key authors on the subject like Roger L. Martin, Tim Brown or Tom Lockwood's are still to publish their books, so I can only quote early reviews.

52. Tim Brown, 2008

Conclusion

Design is a factor of quality and progress that can transform a company, no matter how big or small, giving it the power to redefine its competitive environment. Actively managing this function guarantees control over the risks involved in decision-making and ensures profitable use of a company's design-related investments.

NOWADAYS, DESIGN IS PART OF THE PRODUCTION FUNCTION OF A LARGE NUMBER OF COMPANIES, AND MANY HAVE FOUND IT TO BE A POWERFUL TOOL FOR IMPROVEMENT AND GROWTH.

Over the course of this book, I have shown that investing in design offers positive results and that companies that invest the most in design also tend to grow the most. I have talked about the budding development of a new management model based on the skills of designers, who are arguably the best equipped to tangle with the vicissitudes of the incredibly open and overwhelmingly complex market that organizations must now compete in.

My accounting and finance professor at the University of Westminster used to say that "the more strategic a function [in a company], the less it depends on the account books". In other words, organizations where design is the most critical function, or the tool that gives it its competitive edge, will base their design-related decisions on intuition more than reason. Even though I agree with him, I also strongly uphold that for all remaining organizations, which are still in the majority, that...

IT IS IMPORTANT FOR DESIGN-RELATED DECISIONS TO BE WELL FOUNDED IN TERMS OF CONCEPT, IN TERMS OF FINANCES AND IN TERMS OF STRATEGY.

Design is a project-based activity laden with creativity, a fact that makes it unique but also entails a certain amount of risk. However, as Sirkin and Andrew[53] affirm, "The greatest risk for a company is trying to grow without taking any." In this respect, design is just of the many risks involved in business, and one that offers good results at that. Even so, the everyday operations of a business bring an endless chain of seemingly ordinary decisions that give the company the extra push it needs to survive, not to mention be a successful player in the market. In this day-to-day reality, firms appreciate having tools that provide a rational basis for decision-making. With a tool in hand, if it a company ultimately decides to reject a more rational move and follow its instincts, it will at least know how much of a risk it is taking and why.

DESIGN MANAGEMENT IS A DISCIPLINE THAT DEVELOPS TOOLS TO STRUCTURE AND ADMINISTER A COMPANY'S DESIGN FUNCTION TO MAKE SURE THAT IT SERVES COMPANY GOALS AND TO MANAGE AND RATION THE AMOUNT OF RISK THE COMPANY IS WILLING TO TAKE AT ANY GIVEN TIME.

These tools have to be adapted to each individual case. There is no DESIGN in capital letters. Design is not an absolute; every company must use it as it best sees fit, depending on the stage of its development, the industry, its finances, and its strategic stance. These variables form the basis for a design policy, which addresses the sum of actions and related activities and allows companies to weigh and assign priority to the successive projects that it will undertake as time goes on.

In this book, I have discussed topics that affect how design-related decisions are made and issues regarding the future development of the discipline. I hope that by doing so I will help companies use design more profitably in the future.

A useful metaphor is Bruno Munari's comparison between cooking and design.[54] The apprentice chef learns his recipes by heart, carefully weighing out the ingredients, looking at the pictures, and confiding in the established times, temperatures and steps. However, over time, the same chef stops using the recipes and learns to trust his sense of smell. He begins taking shortcuts and improvises, adding his own special touch to combat boredom and stand out from everyone else. The same holds true for designers and for companies. It is good to know the rules, even if just to bend them later. The best chef is one who takes risks to develop cuisine with a more personal style. Similarly,

THE OUTSTANDING COMPANY IS THE ONE THAT BEST MANAGES RISK TO TAKE ADVANTAGE OF THE FULL POTENTIAL OF DESIGN.

53. Sirkin, Harold and Andrew, James, 2008.
54. Bruno Munari, 1983.

Appendix 1:
on design

CREATIVITY

Even though it is one of its key ingredients, creativity is not exclusive to design. It is an innate human capacity that some people develop more than others. Designers do not necessarily start out more creative than their peers; however, they do work to exercise their creativity, because as professionals, their job is to come up with unique solutions to problems that have been asked a thousand times or more. If not, how could a modern-day designer still develop something as "simple" as a new chair?

In my opinion, creativity is that extra bit of intuition and genius that imbues a well-designed object with what some people call the "wow factor", that special touch that makes people cry out in admiration when they see a solution that manages to be both aesthetically and conceptually pleasing. One recent example of a product that has earned a big "wow!" from consumers is the now world-famous iPod. Some may question whether the true innovation is the object itself or the service that goes along with it, but regardless of one's take, the iPod begins with a highly intelligent and well-designed concept, in terms of both look and interaction/usability, and applies it to a piece of already-existing technology to create an object that has attained veritable cult status, an object that is desired almost as intensely

as it is copied. All things being equal, it is precisely this type of emotional appeals, which generally do not stand to reason, that lead users to choose one product over another in today's opulent society.

In addition to creativity, when examined from a corporate standpoint, the design function must also fulfil the following characteristics:

METHODOLOGY
Design is more than just mere inspiration; it is a discipline that is exercised according to a precise methodology, which has slowly taken shape over time and is now being taught in design classrooms. Not everything can be considered design, and there is such a thing as good design and bad design. Even though experience and talent (and sometimes even luck) can stand in for methodology, or substitute at least some of its phases, companies should be wary of the cliché that all it takes to design is a little inspiration. NO. Logos do not grow in drawers or hard drives. Not all objects work as well (or as badly) as others, and it is simply not true that anyone can design or that no specialist knowledge and skills are involved.[55]

CONSCIOUS DECISION/WILL

In my opinion, design is the consequence of a conscious decision regarding the need to design. This in itself is a sticky topic, and many authors contend that anything that is not a product of nature is design by default. In other words, to such authors, a rush-seat chair like those "that have been around for ages" is design but an eggshell (even though some would consider it the paradigm of packaging) is not. I disagree with this assessment and prefer to think that the rush chair, which has been made the same way in different parts of the world for a long time, is less the fruit of design than the best possible result that could be achieved using the technology and knowledge available at the time it was first invented. Then, because such chairs were perfect at serving their intended purpose, people continued to build them that way, until at some point in the 21st century, when the market was totally saturated, someone thought it would be a good idea to revamp the product and design and make a new rush chair with an irregular structure. The first chair was a product of circumstance. The second, however, was the result of a specific commission, or in other words, a design.

MEETING NEEDS

Design is produced on commission, and it exists to meet a need. Years ago, this was exactly the line of reasoning that was used to distinguish design from art. Design was based on a request, while art was an act of free will. Nowadays, however, more and more art is commissioned but remains art nonetheless; or perhaps there is a sort of artistic design that is different from the uninhibited expression of an artist's emotional state. The controversy as to the difference between design and art is, and has been, long and tediously drawn out, and in my opinion, the topic becomes all but irrelevant in postmodern society. There is no clear boundary between both disciplines, and the underlying nature of a product lies more in the intention behind it than in the product itself. There are no concrete categories, and tracing out divisions is not a particularly productive endeavour. Why should a company refrain from commissioning a piece of art to communicate its activities? Why should an artist keep from using an everyday object to convey his or her aesthetic and philosophical inquietude? Is modern-day art solely aesthetic? Historically, did art only exist for aesthetic purposes?

<u>Without going too far into this issue, I believe that a designer is a designer insomuch as someone asks him or her to use his or her skills as a designer and employ methodology of design to conceive or give shape to a product that currently does not exist, be it as a design, a redesign, a commissioned product or a self-commission</u>.[56]

There is also lively discussion in the discipline regarding the professional and ethnical nature of the needs to be met in a design commission. One thread of thought, inspired by the seminal texts of Victor Papanek[57] and Bruno Munari,[58] upholds that designers must exhibit a strong commitment to society to keep from designing useless objects that perpetuate an unsustainable model of growth. Other designers claim the right to create and experiment in any direction they want, arguing that aesthetics, fun and play are also fundamental human needs. To them, all manner of gadgets, decorative objects and over-designed instruments (e.g., a crank-armed fork for eating spaghetti) have a place in a market that, by definition, is eclectic.

THE NEEDS OF ORGANIZATIONS
OR PEOPLE

When people say that a design meets needs, whose needs are they talking about? The needs of the company selling the product or the needs of the end user? This is the doorway to yet another contentious issue in the discipline. Who do designers work for? Obviously, designers are employed by the company that commissions their work, and as a result they must take the manufacturing capacity and limitations of the company into account when developing a product. However, designers never lose sight of the end user, since observation of end users is ultimately what gives them the tools they will need to develop a formal solution. For example, take a small town that has commissioned a designer to create a series of posters for its local festival. On the one hand, the designer will have to design the poster to minimize printing costs (e.g., controlling the size of the poster to optimize standard paper sizes, making sure the quality of the paper is adequate but not excessive, finding a cheaper way to deal with colour, etc.). At the same time, he or she will make every effort to make an attractive poster that can be read from a certain distance (e.g., from a car parked at a stoplight) and that adequately reflects the local customs in order to incite the interest of the community and encourage participation in the events of the

festival. The same principles can be applied to an everyday object or a piece of decoration, a crane or a motorcycle, a boutique or a sales outlet, an office or a factory. There are also times when there may be conflicting interests between the two parties. For example, a milk producer that reduces the thickness of its cartons to a bare minimum might save a few cents in the packaging, and these savings might have a considerable impact on the bottom line when multiplied over millions and millions of cartons. However, consumers may be critical of the flimsy-looking container or fear that it could break, resulting in spilt milk. The designer will have to reach a compromise between one need and the other, playing with the structure or shape of the carton to reduce the risk, or at least the appearance of risk, associated with thinner packaging materials. A good design will find a solution that is satisfactory to both parties involved.

GOALS

Given the nature of commissions, concrete goals are a necessary part of any design project. For instance, a furniture manufacturer may ask for a new type of office chair or lawn chair. A sports club is likely to commission a mascot for a tournament or to create a new line of merchandising. A dentist might order new offices to accommodate an upcoming merger or to reposition his or her practice in the market. Specialty-tool importers will probably commission a catalogue to explain the benefits and features of their products. A company specialising in food products may call for packaging that is specifically designed for the elderly, young adults who do not have time to cook, or children who have to prepare their own snacks. Regardless of the need in question, commissions will invariably come with a specific goal. At the highest rungs of the design ladder, which I discussed in chapter 1 of this book, designers play an active role in detecting market opportunities and no longer limit themselves to giving shape to other people's ideas.

FREEDOM IN DESIGN
As the final element of the goals underlying a design commission come the related restrictions. It goes without saying that designers do not generally have all of the resources and leeway they would like when resolving a commission. Instead, they typically have to make do with an assigned budget, existing production facilities, and specific materials. Moveover, they must respect their own code of ethics, healthcare regulations, the project timeline and the style of the company's "house brand". <u>A designer's professionalism is measured by his or her ability to resolve a commission within the limits set by the customer, current legislation and the preferences and needs of end users. This being the case, I like to think of creativity as a sort of dressing: every cook has his or her own recipe, and in the end, that is precisely what turns an ordinary handful of ingredients into a salad</u>.

RESULTS
Designers who understand design as the product of a commission based on set goals must be willing to guarantee specific results in order to determine if the project has been a success or a failure. To some, this may be painful and no one likes an exam, but even so, this step is necessary for design that is conceived as a function that makes sense in the context of an

organization. Or as Hollins and Hollins say, "Our fees are paid by the product, not the entrepreneur."[59] As I have already discussed in chapter 9, there is nothing trivial about the topic of results in design, and the issue should not be seen as something that goes against the designer. For instance, the success of commission to design a piece of furniture for a design selection or for the permanent collection of a decorative arts museum cannot be measured in terms of sales volumes. Similarly, if the goal of a commission is to expand the operating margin of a company product line, no one can recriminate the designer if the piece is not later selected for inclusion in a sophisticated trend magazine. Whatever the outcome, it is important to keep in mind that evaluating a design, be it formally or informally, qualitatively or quantitatively, is not a question of personal taste. If companies and designers contend that there are a methodology, process and goals to be met, they must also accept that the results are objective and must be evaluated as such.

55. For a description of the design process and how the process is managed, see any of the many outstanding manuals that design centres, such as the Design Council, have published on the topic.

56. On the topic of self-commissions, it is just as valid for a designer to wait for a customer to show up with an idea as it is for the same designer to approach a customer with an idea for something that would work well in his or her collection. Young (as well as not-so-young) designers often find self-production to be a refreshing escape for their own creative inquietude.

57. Victor Papanek, 1971.

58. Bruno Munari, 1983.

59. Hollins and Hollins, 1999.

II

Appendix 2:
the process
of selecting
designers

IDENTIFYING THE MOST SUITABLE DESIGNERS

Designers usually present their work in a portfolio, or a printed selection of their design projects. When examining a portfolio, companies should keep in mind that designers rarely complete projects on their own, meaning that it is important to try to find out the exact role the designer has played in each project. A typical example is a designer who has been working for a studio or company and would now like to try his or her luck as a freelancer. The portfolio will naturally show off all the work he or she did in his or her last job; however, when analysing this work, whether good or bad, companies need to know that the outcomes were the result of a team effort. A designer's production can change in a new professional environment — for better or for worse. If a company is looking for an outside supplier or studio instead of an in-house designer, it is the project manager in the larger structure who will most affect the final outcome of the collaboration. The situation is analogous to the influence of an account manager at an advertising agency or an individual surgeon at a large hospital.

One idea that is worth dispelling is the myth of "experience". A designer who has spent years working on refrigerators does not necessarily have to spend the rest of his or her life doing

refrigerators, just as a person who has designed a fast-food catering service may be equally able to reflect on the inner workings of a notary office. The basic practical tools of a designer (thinking comprehensively, creativity, structured project framework) can be, and indeed are, applied to a wide variety of subjects with the same successful outcome. What's more, having a diverse base of experience can even help designers better understand problems and develop more innovative solutions.

The financial aspect is another important issue to keep in mind when selecting a designer. The most expensive team is not necessarily the best one for all companies and projects. Many smaller organizations have fallen into the trap of going after the industry's most prestigious designers only to find themselves overwhelmed by vastly divergent methodologies and design fees that greatly exceed their means. There is a suitable designer for every project and every company. The best fit is the one that can respond to the specific needs of the client at any given moment, not the designer who has won the most awards or has the best reputation in the media.

CONTESTS
In recent years, it has become quite fashionable for companies and associations to convene design competitions for nearly everything: posters, logos, furniture, and virtually any other product

one can think of. In many cases, these contests have come to replace the older method of first selecting a designer and then trusting in his or her work. Slowly, competitions are coming to be the most commonly used method of identifying the best candidate for a job, and for many firms, other methods are becoming obsolete.

In theory, design competitions provide impetus and incentive for the development of specific areas of design, and they should be understood and appreciated as such. In practice, however, they have often proved to be a cheap way of culling good ideas, and many companies have abused this fact, confident in the knowledge that there is a large number of designers who are willing to present their work and unwittingly validate the competition, no matter how badly conceived it may be.

Until recently, design competitions were governed by a set of internationally accepted rules. Now, most of these norms have fallen into disuse, but there are still some minimal guidelines that should still be followed by entities in the field, whether design centres or associations of designers, insofar as they are the organizations that typically offer support to companies that convene competitions or offer design awards. In the very least, design competitions should:

- Identify the jurors at the beginning of the competition (by full name, not as "a well-known designer" or "a representative of x organization", which are oft-used but generally uninformative formulas).
- Ensure that a majority of jury members are knowledgeable in design and thus able to make an informed decision.
- Compensate the jury for their participation (thus avoiding early withdrawal of jury members, delegation of duties to others, etc.).
- Offer a reasonable amount of time for submissions.
- Not exaggerate the submission requirements, i.e., the submission should be an idea, not a finished project.
- Guarantee the intellectual property rights of all entries.

Companies that are not sure how to proceed should turn to professionals or qualified organizations and/or in the very least refer back to well-established contests that enjoy a certain degree of prestige among industry professionals. Also, in order to generate interest and raise awareness of a competition, strenuous efforts must be made to advertise it. Doing so will not only benefit the participants, but the contest organizers as well. Once a contest has been launched and the initial outlay for organization made, the best way to cash in on the investment is to make sure that the winner appears in the media to talk about the award (and, by extension, the institution or company that sponsored it) as much as possible.

<u>Open competitions can be useful as a method for discovering new talent, but generally speaking, they represent a great loss of collective energy</u>. A great deal of time and manpower is dedicated to something that a team with a good brief could do in a short time, often with a higher chance of a satisfactory result. Many established design professionals are also reluctant to take part in open competitions, since they never know who they are competing against and would rather not run the risk of coming in second after a student or an amateur.

At the other extreme, students are also loath to participate in design competitions. On the

one hand, most are saturated with competition announcements, and on the other, they are often quite busy with school projects and are unable to devote time to anything else. Students are also aware of the fact that when they enter competitions, the benefits for them are minimal (modest prize, etc.) but that they, in fact, contribute a significant amount of ideas, both good and bad, to the company. On top of that, their ideas are filtered by a professional jury, which not only selects the winner of the competition by also forms an opinion on each of the candidates. This is without doubt a good deal for a company, especially if it belongs to a traditional industry where innovations are hard to come by.

Even if the organization takes every possible precaution, there is no guarantee that a contest will produce a positive outcome. In a world so jam-packed with signals, it is difficult to do a task well without knowing exactly who one is speaking to and what level of experience they have. It is not unusual to end up with something already on the market, and it is very dangerous to guarantee in the contest rules that the winning proposal will be adopted (or produced) without prior assurance of a minimum level of quality.

In my opinion, the most sensible competitions

are closed contests that seek the opinions of several professionals before launching in one direction or another. Generally, the participating designers are paid for their work under the pretext that they are advancing a portion of a larger project and presenting a minimally formalized solution to the jury. The benefit of this system is that the company does not feel like it is wasting time, and the candidate does not have the sense of reaching for the moon. The company knows it has picked the best option, and the participating professionals are compensated for their work, regardless to who ultimately gets the full contract.

Companies that do not want or do not have the means to advance payment can also convoke a <u>merit-based contest</u>, in which each of the selected designers submits a portfolio of finished projects. The company may also specify a predetermined budget for the project, in which case the designers who enter the contest understand the financial constraints in advance, or the company can ask for a budget proposal along with the portfolio. In either of the two scenarios, it is important to begin with a clear definition of the project to make sure that both sides understand each other.

Designers frequently complain about competitions, since their work is based on a relationship of

trust with the customer, and starting off with an auction does not seem like the best way to get things off on a good foot. In light of the foregoing discussion, these objections are

> FOR EXAMPLE:
> Take a merit-based competition between five teams to design the packaging for a new line of cosmetics. If the company asks for a budget proposal, it has to specify exactly what it wants the designers to quantify. Structural packaging and graphics or just graphics? If just graphics, is there an already-existing container or does one have to be found and agreed upon? How large is the range and how many sizes does each product come in? Are there restrictions in terms of materials and/or deadlines? And so on and so forth. In other words, the company needs to prepare a solid, well-founded brief to make sure that all of the competing teams start on the same page.

understandable; however, it is also true that nowadays, many large corporations convene similar competitions between law firms, for example, when it comes to assigning an extensive issue.

III

Appendix 3:
the network of
design services

There are organizations in every country of the European Union that provide design services.

DESIGN PROMOTION CENTRES

The purpose of design promotion centres is to raise awareness of design and provide support for companies that are about to introduce a design function. They generally offer a wide range of activities, serve as point of reference, and are the first place companies can turn to for information and assistance. Present-day design centres have become considerably more professional, and most are managed by experts with the relevant background, since their work is critical to the development of business connections in the area. Among their various tasks, they conduct research and provide channels for disseminating design-related information (exhibitions, conferences, etc.). They also serve as the point of connection between design and the public administration. As such, contact between centres and businesses is extremely important as a way to ensure that public policy decisions are based on realities in the market. In the past, design promotion centres were usually publicly funded. This model, however, is now giving way to a more mixed framework of public funding plus private sponsorship. In most countries, there is a state agency that coordinates national design policies and the network of

regional design centres.

DESIGN SUBSIDIES
Up to now, economic policy-makers in most EU countries have considered subsidies to stimulate competitiveness in overall production, and such plans tend to include design for the beneficial effect it has on corporate bottom lines. Some design centres help determine the direction for these grants and may assist with the administration of the funds; however, the activation and use of these monies is invariably the domain of the corresponding public institution, which normally acts in accordance with the country's prevailing industrial policy objectives.

SUBSIDIES TO PROMOTE DESIGN ABROAD
<u>Design plays a major role in building national "brands", gives notoriety to big-ticket products, and raises awareness among people with greater purchasing power or a larger sphere of influence</u>. As a result, it is common for design to form part of programs run by state agencies to promote foreign commerce.

DESIGN SCHOOLS
Regardless of whether they are large universities or small specialised schools, virtually all design programmes offer a variety of opportunities for continuing education. Design Management courses are also available, although the selection is

considerably more limited. At any rate, courses are a very beneficial, not only to review issues in the field and learn new techniques but also to cultivate important professional contacts. Most traditional design schools are more than willing to accept offers to collaborate with companies. Such collaborations can be interesting and fruitful when working on experimental and/or research projects, but they are not an appropriate venue for commercial undertakings. <u>When a school offers professional services to a company, all parties involved end up losing</u>: the students who are diverted from their studies to take part in an uncompensated project; the company, which is left without any guarantee of quality or timely delivery; and the school, which actually lowers the market price of design services to the disadvantage of their customers (the students) and debases its own product by suggesting that the work of a professional is the same as the work of a student, which is essentially tantamount to saying that education does not make a difference.

ASSOCIATIONS OF DESIGNERS

Associations of designers exist in great abundance and are usually grouped by specialisations and/or geographic proximity. Their main purpose is to defend the interest of design professionals, but they also frequently get involved in promotional activities, such as exhibitions, organizing competitions and awards, lectures,

conferences, etc. Some designers' associations actively seek collaboration with companies to improve their funding, since sponsorship usually offers rather attractive compensation.

GALLERIES AND MUSEUMS

Nowadays, there is more and more gallery and museum space devoted to the promotion of design, both in self-curated events and in activities organized by other groups. In some places, applied and decorative art museums play the role of design museums and host exhibitions that help define design and demonstrate its contribution to society. Galleries, on the other hand, tend to cater to the more experimental or artistic side of the discipline.

BOOKSTORES AND LIBRARIES

Set somewhere in the dynamic between the great repositories of culture and small speciality bookshops, small businesses dedicated to design are flourishing. The reduced size and high level of specialisation of these businesses has made them a point of reference and a meeting place for experts. Such shops frequently offer incentives like consultations or payment plans in order to boost customer loyalty, a topic of interest to any company. Specialised design libraries are generally housed in academic institutions and are not typically open to the wider public.

PUBLISHING HOUSES AND THE MEDIA
There are publishers who specialise in design and other companies that publish a relatively broad range of books on the discipline. While it is fairly easy to find illustrative books in the design sections of bookstores, it is more difficult to find practical texts and textbooks. Professional design magazines and journals tend to be few and far between, but they typically offer high-quality information. Now, there is a clear tendency to offer a broader panoramic view of design, which contrasts with the higher specialisation that characterized such publications in the past. Design journals also publish news related to specific companies, but it is not easy for companies to influence what is published or when. Periodically, people will toss around ideas for a television show about design, but for the moment, it seems that no one has stumbled on the proper formula — at least not yet.

AWARDS AND YEARBOOKS
Both design prizes and yearbooks represent good opportunities for companies to make themselves known in the industry and to identify new and interesting designers to participate in their projects.

IN THE INTERNATIONAL AREA
Every year, new activities, such as conferences,

exhibitions, etc., are added to the international design circuit. It is important to pick and choose well, but in general, these events are excellent occasions to build up a network of contacts and learn more about the discipline.

IV

Appendix 4:
the keys to a
reputation in
design

AWARDS

There are two things to keep in mind about awards. First, the prestige associated with the competition is determined by who is on the jury. Second, aside from the prize money that may be offered, the return on the investment in participation comes in the form of the promotional opportunities available to the winner: the chance to take part in events and conferences, exhibitions, catalogues, etc.

> FOR EXAMPLE:
> If a public institution wants to offer a design excellence award, the best way to make it worthwhile for everyone involved is to schedule the winners to appear in the media all throughout the year, not just on the day of the awards ceremony. This means taking the winning designers into account for the remainder of the activities arranged by the institution over the course of the year (e.g., conferences on specific topics, round tables, research projects, etc.). By doing so, both the institution and the winners will get a proper return on their investment. Besides, it does not make much sense to say that someone is the best and then not use them as an example.

Companies sometimes think it is complicated to opt for an award. They have to submit an application and make at least a minimal effort to come off well with the jury, since the same story told different ways can trigger different reactions. Companies should not hesitate to hire an outside person to prepare the dossier, not only because it will probably increase their chance of winning, but because they can also make use of the resulting piece for other promotional purposes. It could be the basis for a corporate brochure; it might be an excellent starting point for a corporate presentation; it could be used as a press dossier, etc. A person from the outside, a designer, if at all possible, will naturally bring a fresh outlook on company projects and activities.

EXHIBITIONS

At one time or another, a company may be asked to include some of its products in an exhibition. Once again, the company should evaluate the costs associated with participation, the prestige of the curator and the organizers, the location or locations of the exhibition, and the planned promotional activities. In an ideal scenario, the company should make itself or the designers available to the press office to take advantage of any media opportunities, such as interviews, articles or special reports, that may come up.

CONFERENCES
Companies are also frequently asked to take part in conferences, seminars, lectures, etc. to describe and discuss their own particular "case". Sometimes, companies can take better advantage of these opportunities through public relations on to the institution organizing the event. At any rate, it is important to make sure that the conference is sufficiently well planned, will be well attended, and that the make-up of the audience is as expected, e.g., students if they target audience is students or business people if it is business people.

THE PRESS
The design press is just as independent and professional as the press in other industries. Establishing good relationships with the media makes the job easier for them, but companies should never demand or insist on coverage by the media. <u>In the past, journalists did not know whether to include design in the culture or the economy section. Now, "design" is a separate section, but there is also a veritable avalanche of news bits competing for the limited space available</u>.

FAIRS AND TRADE SHOWS
The very idea of a "design fair" is controversial, because to host one, there would first have to be a general agreement on a single definition

of what "design" actually is. Currently, the "in" event for European design is the Milan Furniture Fair, though every now and then, other smaller, more specialized events come into vogue, since they can sometimes offer better results depending on one's particular objectives. Magazines are a good source for information on what to attend and where to exhibit. The *100% design* events organized by a British company in a variety of the world's major cities are another alternative for a very specific type of design; however, they tend to have a strong bias towards furniture and decoration.

ASSOCIATIONS OF COMPANIES WITH A STRONG DESIGN COMPONENT

These are private associations, and they usually have relatively closed admissions policies. The idea behind them is for companies to work together to defend each other's interests. In addition to lobbying, they may also carry out joint research projects, present together at trade fairs, etc.

References

Bessant, John *et al.*
2005, *Management of creativity and design within the firm*, DTI "Think Piece", Department of Trade and Industry, UK (Now: Department for Business, Enterprise and Regulatory Reform, www.berr.gov.uk).

Best, Katrhyn
2007, *Design Management,* AVA Publishing, Lausanne.

Borja, Brigitte
2002, *Design Management,* Éditions de l'Organisation, Paris.

Borja, Brigitte
2004, *Design management: Using design to build brand value and corporate innovation,* Allworth Press, New York.

Borja, Brigitte
2007, *Le design de demain se prépare aujourd'hui dans la Silicon Valley: "Design thinking" "D-School" Université de Stanford,* Design Plus Magazine no. 29, Centre de Design Rhône-Alpes, Lyon.

Borja, Brigitte
2008, *A theoretical model for design in management sciences: The paradigm shift in the design profession, from management as a constraint to management science as an opportunity,* Design Management Journal, Volume 3.

Brown, Tim
2008, *Design Thinking,* Harvard Business Review, June edition.

Capella, Juli, and Úbeda, Ramón
2003, *"CoCos, copias y coincidencias. En defensa de la innovación en el diseño",* Electa, Barcelona.

ddi, Sociedad Estatal para la Promoción del Diseño y la Innovación (Spanish State Agency for the Promotion of Innovation and Design)
2005, El impacto económico del diseño en España, ddi, Madrid.

Design Council
2005, *Design Index: The impact of design on stock market performance*, Design Council, London.

Design Council
2006, *The prime numbers*, Design Council Magazine num. 3, London.

Design France and Tremplin Protocoles
2002, *Les pratiques du design en PMI, rapport d'étude*, Ministry of Economy, Finances and Industry, Paris.

Erlhoff, Michael and Marshall, Tim (Eds.)
2008, *Design Dictionary, Perspectives on Design Terminology,* Birkhäuser Verlag AG, Basel.

Haberberg, Adrian and Rieple, Alison
2001, *The Strategic Management of Organisations,* Prentice Hall, Harlow.

Haberberg, Adrian and Rieple, Alison
2008, *Strategic Management, theory and application,* Oxford University Press, Oxford.

Hamel, Gary
2007, *The future of management,* Harvard Business School Press. Boston.

Hertenstein, Julie *et al.*
2005, *The impact of industrial design effectiveness on corporate financial performance,* The Journal of Product Innovation Management, 2005; 22:3-21.

Hollins, Bill and Hollins, Gillian
1999, *Over the horizon,* Wiley, Chichester.

Kelley, Tom
2001, *The art of innovation,* Harper Collins Business, London.

Munari, Bruno
1983, *¿Cómo nacen los objetos? Apuntes para una metodología proyectual,* Gustavo Gili Diseño, Barcelona.

Nomen, Eusebi
2005, *"El valor razonable de los activos intangibles",* Deusto, Barcelona.

Papanek, Victor
1971, *Design for the Real World: Human Ecology and Social Change,* Pantheon Books, New York.

Phillips, Peter
2004, *Creating the Perfect Design Brief: How to Manage Design for Strategic Advantage,* Allworth Press, New York.

Sirkin, Harold and Andrew, James
2008, *Explota tu innovación,* Lid Editorial Empresarial, Madrid.

Thackara, John
1997, *Winners!,* BIS Publishers, Amsterdam.

Online references

Abengoa:
www.abengoa.com

Amazon:
www.amazon.com

British Standards:
www.bsi-global.com.

Bund Deutscher Graphik-Designer, e.V.:
www.bdg-designer.de

Design Council:
www.design-council.co.uk

Design Week:
www.designweek.co.uk

Hasso Plattner Institute of Design at Stanford:
www.stanford.edu/group/dschool

H&M:
www.hm.com

IDEO:
www.ideo.com

INTI:
www.inti.gov.ar

Ikusi:
www.ikusi.es

Impiva:
www.impivadisseny.es

Instituto de Diseño y Fabricación (Design and Manufacturing Institute):
www.institutoidf.com

"la Caixa":
www.lacaixa.es

McDonald's:
www.mcdonalds.es

Illinois Institute of Technology - Institute of Design:
www.id.iit.edu

Natura Bissé:
www.naturabisse.es

OCDE:
www.oecd.org

Procter & Gamble:
www.pg.com

SAP AG (Systeme, Anwendungen und Produkte):
www.sap.com

Sociedad Estatal para el Desarrollo del Diseño y la Innovación (ddi) (Spanish State Agency for the Promotion of Innovation and Design):
www.ddi.es

Sony Corporation:
www.sony.net

Swedish Industrial Design Foundation:
www.svid.se

Acknowledgements

You can spend your whole life sizing up what others have written and how they've written it, doling out measured doses of sharp, perceptive, even witty criticism. Still, there is nothing that can prepare you for the overwhelming feeling that comes when you set out on the arduous task of writing something all your own and wish you could just turn back...

The fact that I made it out on my two feet (well, almost) is thanks in no small part to my family- including my late parents who are always close to my heart- who have been there every step of the way and supported me any possible way.

In terms of the book itself, I would like to thank Eduardo del Fraile for his patience and for the excitement and energy he put into its design. I would also like to thank my editor for trusting in me from day one — or maybe even earlier.

Of the long list of people deserving thanks, I would like to mention Salvador Maluquer and Mai Felip, who taught me how to work; my teams at AITPA, BCD and DDI, whose fellowship helped me grow; Earl Powell, Alison Rieple and my classmates at the University of Westminster, at whose side I learned everything I know about design management; and my friends and colleagues Manuel Lecuona, Carlos Laorden, Pedro Feduchi, Thomas Steinborn and Neus Arqués for generously investing their free time to revise this text. And finally, I would of course like to thank Jacobo, just for being there.

Notes